HIDDEN
HISTORY
of
FARGO

Danielle Teigen

THE
History
PRESS

Published by The History Press
Charleston, SC
www.historypress.net

First published 2017

Manufactured in the United States

ISBN 9781467136594

Library of Congress Control Number: 2017938339

CONTENTS

CONTENTS

ACKNOWLEDGEMENTS

Writing this book actually started years ago, when I was a child dreaming of becoming an author. Through the years, many people have contributed to this dream becoming a reality—whether that was my parents for reading the stories I would write on long car rides, my high school English teacher who encouraged my writing ability or college professors who nurtured my skills.

This book has been a labor of love, both in terms of the topic and the time it took to put everything together. Even though I am a native South Dakotan, I have thoroughly enjoyed researching Fargo's history. I must thank former NDSU archivist Michael Robinson for his ceaseless assistance while researching for other projects because his excitement and expertise fueled my love of Fargo history.

I'm grateful to my co-workers at Forum Communications for their support and interest in my work, as well as friends and family members who supported my work and were intrigued by stories I was telling.

The process of writing a book is strenuous and requires a great deal of time and focus. I am forever grateful to my husband, Kevin, for his endless enthusiasm for this project and his understanding about the commitment necessary to accomplish this feat. Thank you for your input, feedback and valuable edits.

When deciding what to include in this book, I tried to consider pieces of Fargo's history that many people might not know much about, but I realize that Fargo's history is a rich tapestry of stories about countless people whose

contributions to its establishment should be acknowledged. This book is not meant to be comprehensive; it is a mere sampling. Far more prolific historians than I have documented Fargo's incredible history, and I have attempted to honor their work through mine.

Part I

Introduction

In January 2015, the Fargo-Moorhead Convention and Visitors Bureau unveiled a rebrand of its organization and, essentially, the community. Instead of eschewing the distinction of this place and its people—the cold, the friendliness, the folksy nature—the CVB embraced it. Highlighting qualities like ingenuity, creativity, quiet strength and innovation, the organization single-handedly captured the energy of the area by describing in detail just what makes this place so different: we're fiercely independent and naturally gregarious. We're down-to-earth and intensely innovative. The Fargo-Moorhead community demonstrates a vitality and momentum only seen in large metropolitan areas. It's why the organization adopted the tagline "North of Normal" to embrace the notion that Fargo and its residents are something exceptional.

What does all of this have to do with a history book about Fargo?

Because the same qualities that set the community apart now in the twenty-first century emerged nearly 150 years ago when Fargo welcomed its first citizens. Those pioneers were the true innovators because they built a thriving community from the dust of an unsettled prairie using only their own resourcefulness and determination.

This is a hidden history of Fargo, but history is rarely truly hidden. People just don't know where to look. For the quickest history lesson, go to downtown Fargo. Then look up. There, in the stone façades of some of the oldest buildings in the city, you'll see names etched in stone—names of the business moguls who came to this city with nothing and left as legends. But

you won't see the names of every individual who left an indelible mark on the city in its early years; those stories are the ones truly hidden.

Fargo's hidden history has always been in plain sight; most just don't take the time to learn it.

I'm honored that you've taken the time. You won't be disappointed.

Chapter 1

WHAT'S IN A NAME?

All the Ways We've Called Fargo Home

Fargoans can thank the railroad for their city. As the Northern Pacific (NP) Railroad crept westward, government officials realized the need to stake claim to create cities where rail stops would be. Having a stop at the crossing of the Red River "was looked upon by nearly every one as of great importance" because the city had the potential to become "head of navigation on that stream" and was located "in the center of a very rich agricultural district."[1]

But the NP knew settlers were watching—and waiting—to see where the new towns would be placed so they could snatch up the land. Settling Moorhead turned into a gold rush, not for "gold-bearing lands, in the literal sense, but land on which they hoped to build sizeable fortunes."[2]

Eager would-be Moorhead residents bought up sections of land where they thought the railroad would cross the river, not realizing the government had already secured the Moorhead site clandestinely. "But the land company was finally forced to sell its Moorhead site at reduced prices to the settlers who had bided their time and finally achieved their goal. The location of Fargo is a direct part of the story of the location and settlement of Moorhead."[3]

As a government agent, Thomas Canfield was tasked with staking Moorhead, and he learned his lesson when he was later assigned to site Fargo. Early on, Canfield thought Moorhead would be the major city in the Red River Valley, with its higher elevation and lawful protection (as opposed to the unsettled Dakota Territory). Keeping the site a secret was necessary because Canfield had recently helped the railroad form the

Lake Superior & Puget Sound Land Company as a subsidiary to buy land and promote its own townsites. (Canfield was named president of the organization; he was also an early supporter of bonanza wheat farms.) His ruse to baffle would-be Fargoans involved traveling four miles north of Moorhead where a bridge had already been platted and continuing west. That was just one of nine tracts purchased in the elaborate hoax to deceive settlers.

Canfield is considered one of the great railroad promoters and an important figure in the early years of the NP Railroad. He had "great faith in this plan from the first time that he saw it, and he spent the rest of his active life in making it a reality."[4] Selecting the site was no small task because the general concession was that the location where the NP Railroad crossed the Red River would give rise to a great city west of Minneapolis.

A few of those early Oakport residents were Jasper Chapin, Gordon Keeney and Charles Roberts, men who would soon move to Fargo and make important contributions during the city's early years. Andrew Holes was another one of those early settlers, and his wife later recalled those wild and wooly first days when a new community was just getting started:

> In the uncertain days of 1871, when settlers were not sure where the railroad route would be put through, tents were the principal abode. Mr. and Mrs. Holes first pitched their tent at a point three miles north of Moorhead and later moved it to a point within the present townsite.…Living in a tent was the easiest way to cope with the changing circumstances of the early days, Mrs. Holes says, as families shifted their abode with every new rumor as to where the railroad was going through.[5]

No-Name Community Called Centralia Briefly

During those early days, the new community didn't have an official name. Only about thirty families lived there, but a post office was established—it was called Centralia, which meant the town was too. A name legitimized the area.

Keeney was appointed postmaster, and he posted a "Law Office" sign on the door and a "Land Office" sign in the window. A grocery store—in a tent, of course—was set up nearby. Keeney and a few other attorneys sent a petition to the U.S. Post Office asking that the town be officially named "Centralia" as well; the petition was approved on October 6, 1871.

"Centralia" didn't stick, though, because at the same time the petition was en route to the post office, NP directors and its land brand, the Lake Superior & Puget Sound Land Company, wanted the new town named for one of their own: William G. Fargo. A handful of residents began calling the city "Fargo" despite what the post office claimed. A telegram was sent in September instructing that the west side of the Red River was to be called "Fargo," and the new petition was approved by the post office on February 14, 1872.[6]

Yet the new community wasn't just Fargo. Two distinct sections of the town developed, each with its own moniker.

FARGO ON THE PRAIRIE

As the Northern Pacific Railroad neared the Red River, General Thomas Rosser was sent to the Fargo side to establish his headquarters in September 1871. He was serving as the head of the NP Engineer Department and used his military experience to set up a thrifty camp of some fifty tents, which included an office, sleeping quarters and eating spaces. In addition to the men serving in his unit, Rosser's camp also included wives and children, resulting in "the excitement and activity that one finds at a typical military post on the frontier."[7]

Spending a winter on the North Dakota prairie in a tent was something to behold, being at the mercy of Mother Nature and her wintry fury. In addition, residents had to tolerate the "uncouth denizens" of Fargo in the Timber.

Rosser was a Civil War soldier who ended up sparring with some of the great historical figures of the time, including General George Custer (with whom he was friends from back in the West Point Military Academy days) and Sitting Bull. During the Civil War, Rosser fought for the Confederate side while his friend Custer served in the Union army. After the war, Rosser studied law and eventually became an engineer for a Philadelphia railroad company.

Rosser and his southern belle wife, Betty, as well as a few children, stayed in Fargo for those early years but soon established permanent residency in Minneapolis, leaving the prairie tent city behind. They'd recently lost a newborn and decided to move somewhere that would offer closer access to medical care.

In 1881, he took a job with the Canadian Pacific as its engineer. Rosser "is credited with building most of the line from Winnipeg west to the Pacific—

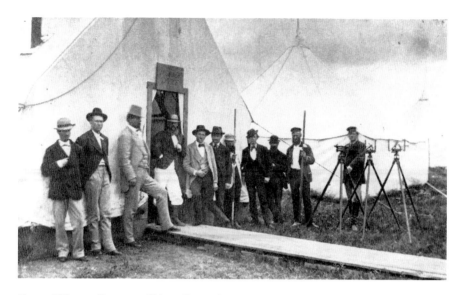

General Thomas Rosser and his staff pose in their camp at Fargo during construction of the Northern Pacific Railroad. *Minnesota Historical Society.*

reached in 1886. He had now accumulated some wealth and was 50 years old—somewhat weary of the rugged life on the frontier."[8] His family moved from Minneapolis to Virginia in 1885, and he joined them a year later to become a gentleman farmer. In the Spanish-American War in 1898, he served as a brigadier general, and in 1905, he was appointed postmaster at Charlottesville. He died in 1910.

FARGO IN THE TIMBER

As the winter of 1871 approached, a new community sprang up, this time by the river to about Second Street South to Front Street (now Main). The community consisted of transient railroad workers, immigrants and ruffians of African American, Asian and Jewish descent who lived in "dilapidated housing of Lower Front Street."[9] The "roaring camp" also contained a number of tent hotels, saloons and bordellos. It was called Fargo in the Timber, a "place where girls were few and no better than they should be. A place where quarrels were settled by bullets. A place of violence and horseplay."[10] "The constrast between Fargo in the Timber and Fargo on the Prairie…was sharp. In the one settlement was disorder and confusion, combined with a gay frontier robustness. In the other

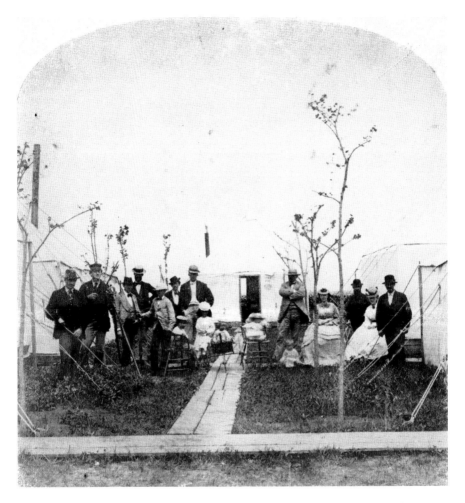

At its start, Fargo was a tent city, divided into the civilized Fargo on the Prairie and the more rowdy Fargo in the Timber. *Institute for Regional Studies, NDSU, Fargo.*

was order and discipline, and despite the flimsy nature of its habitations, comfort and even refinement."[11]

Those who lived in the Timber were aware of the bad reputation, so they had some fun with the Prairie residents. Once, Timber residents intercepted a wagon full of potatoes that was en route to Rosser's camp; another time they removed turkeys and chickens from a sleigh on its way to the Prairie mess tent.[12]

The ramshackle shantytown wasn't home to just miscreants. The man who would become Fargo's first mayor, George Egbert, lived in a tent in

Fargo in the Timber—near Gordon Keeney, in fact. Egbert operated a saloon, and Keeney served as postmaster.

An issue arose about ownership of the land and possible Indian claims to the land. When the Lake Superior & Puget Sound Land Company decided to dispossess land, the settlers and squatters needed to be removed. The company secured an order from Washington to remove all trespassers and arrest anyone selling alcohol.

On February 17, 1872, troops arrived from Fort Abercrombie, piquing the curiosity of everyone. Keeney and another Timber resident were selected to approach Rosser about their intentions. He lied and explained the soldiers were in town to deal with Indians. Not quite.

The next morning, everyone in the Timber awoke to find soldiers at the door of every log house, tent or dugout. Everyone was arrested, including Keeney, though he was released by noon that day.

Timber residents were furious; some believed Canfield was responsible for the raid. Others thought Moorhead saloon owners caused the upheaval. Eventually, Congress extinguished the Indian claim two years later, allowing the Timber squatters to rest easy on their parcels of land.

After all the ruses and kerfuffle, Fargo was platted and officially became a city on April 12, 1875. During those early days of Fargo, Keeney played a critical role in the community. Not only did he operate the post office, Keeney also served in a number of other capacities, such as "attorney at law, notary public, land agent, and generalissimo in helping people into and out of trouble."[13]

Keeney was a young man when he came to Dakota Territory—he was just twenty-five years old when he arrived in fledgling Fargo, a lawyer from Michigan whose Duluth practice proved unsuccessful. He actually first worked as a cook on a wagon train owned by the man who would eventually become Moorhead's first mayor. Keeney officially served as postmaster until April 1873. At that time, he turned his efforts toward establishing an Episcopalian church.

> *Its first name was Christ Church, later Gethsemane, then Gethsemane Cathedral. When the Cass County Agricultural Society was formed in 1873, he became secretary and helped in promoting the first county fair in Fargo. He took a prominent role in organizing the first July 4 celebration. He was appointed assistant U.S. District Attorney in 1873.*[14]

Keeney later bought a printing press, which he used to start the first paper, a weekly called the *Fargo Express*, on January 3, 1874. He'd been writing

articles for Twin Cities newspapers since coming to the Dakota Territory, so starting his own paper wasn't that far out of character for him. He'd organized the printing company with the help of several other Fargo pioneers, including Charles Roberts and Andrew McHench. "The office of *The Fargo Express* stood in the middle of Broadway at the intersection of Northern Pacific Avenue, and while the paper was not a financial success, it left its mark on the affairs of Fargo, and will be remembered as a potent factor in the early history of the city and state."[15]

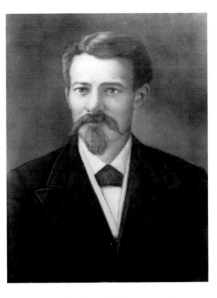

After operating Fargo's first post office, Gordon Keeney went on to become an influential citizen of the newly created city. *City of Fargo.*

Keeney sold the paper to E.B. Chambers of Glyndon, who acquired two other newspapers and combined all three to create the *Fargo Times.* Once city government organized in 1875, Keeney took an interest, serving four terms as a member of the council. His dedication to the city was solidified when he built the Keeney block in the 1880s; the businesses housed inside included a furniture store, a music shop, a glassware store, a real estate office and a dental practice. In 1884, when the Continental Hotel was destroyed by fire, the heat was so great that it cracked the windows of the Keeney block building.[16] However, the fire of 1893 swallowed up the Keeney block. Eventually, Keeney, his wife, Lottie, and their six children moved to San Diego, California, where Keeney died in 1918. He is buried in Michigan.

Fire Destroys Fargo but Residents Persevere

The fire of 1893, known as "the great conflagration," was a major hiccup in the city's history. Interestingly enough, the city's firemen were busy putting together their annual tournament, scheduled for June 13. Six days before that could happen, however, a small fire started in a store on Front Street. "This was at 2:15 in the afternoon of June 7, 1893. The wind was blowing a perfect hurricane from the south. In less than five minutes after the first

The fire of 1893 destroyed a significant portion of the business district in Fargo. *Institute for Regional Studies, NDSU, Fargo (2113.14.1).*

alarm was turned in, the whole building in which the fire originated was a mass of seething flames."[17]

That small fire grew quickly and enormously, engulfing much of the young city's most important establishments. The fire destroyed a significant portion of the business district, including the Citizens National Bank, Alex Stern's block, Peter Elliott's hotel, city hall, the Yerxa Hose House, the Masonic block, the Hagaman block, the Columbia hotel and more, until it finally extinguished itself at the tracks of the Great Northern railway.

Yet a flurry of activity followed, with relief committees immediately set up, as well as Elliott's kitchen and dining tent. Approximately $4 to $5 million worth of property was destroyed, but plans were immediately drawn up to rebuild and improve; the citizens were undaunted and determined. Wooden sidewalks were replaced with concrete ones, and new ordinances required firewalls and inspections; the sewer system was upgraded, and fireproof masonry replaced frame and brick structures.[18]

CITY ON THE RISE

Not only was the development of the railroad crucial to Fargo, but it also indelibly affected the entire state. Because of where the railroad lines entered Dakota Territory at such a northern point, having the capital of the territory at Yankton—in extreme southern Dakota Territory—made no sense. That's how Bismarck ended up serving as a capital, and eventually, the entire swath of territory was divided into two states.

Fargo's history, as well as that of the entire Red River Valley, is inextricably linked with the development of the railroads. The route through North Dakota inherently affected lines of trade, and a different path would have undoubtedly changed how much of Dakota Territory developed in the late 1800s. "The railroads did not make Fargo, but they made Fargo possible....Railroads were metallic monuments to the courage and enterprise of their early builders."[19]

As soon as the railroad tracks were laid, Fargo's fate was sealed. People from all sections of the East began settling here, and by 1880, "Fargo had assumed all the characteristics of a city of speculative push."[20] People took notice of the city's growth, and most acknowledged Fargo's earned reputation for being a boomtown.

> *Fargo claims the proud appellation of the "Queen City of the Far West" and to all appearance is justly entitled to it. Her growth has certainly been phenomenal in many respects and far exceeds the expectations of the most sanguine of the pioneers of ten years ago. As if touched by the magic wand of Hermes, a city of 2,500 people has within eight years sprung up, which has already doffed its mushroom semblance and presents in its tour ensemble the unmistakable evidences of solid and substantial prosperity.*[21]

But this intense growth did not happen overnight, nor did it come without its share of setbacks and strain. But, like so many stories associated with the plains of North Dakota, perseverance prevailed.

> *By such adjustment* [North Dakotans] *can, in the future, as they have in the past, continue to attain the ever rising standard American values and at the same time be themselves—moral, courageous, outspoken individuals, lean and fit, friendly, democratic and hospitable, energetic and aggressive. For they live, not in the urban world with its lonely crowd, but on the*

In 1879, downtown Fargo included the Headquarters Hotel, A.E. Henderson Hardware, Luger Brothers furniture store and a livery stable. *Institute for Regional Studies, NDSU, Fargo (2029.8.12).*

prairie, where the scarcity of population emphasizes the worth of the individual, where each is needed and each can do his part in the upward struggle of a rural society.[22]

By the early 1900s, Fargo was on the rise and would continue to prosper into the twentieth century, never forgetting the stories of the early pioneers who built it. Their early success is a source of fierce pride. "Fargo today is a great little city—the commercial, educational, religious, social and political center of the state. It is constantly growing and almost every item of statistics by which comparisons may be made of one year with another shows a steady, rapid and natural growth."[23]

Part II

Railroad Rulers:
Many of City's Namesakes
Never Stepped Foot Here

Chapter 2

WILLIAM G. FARGO

The coming of the railroad allowed the city of Fargo to flourish on the dusty prairie of the Dakota Territory. The men who directed the rail system to the northwest were honored by having the cities named for them. The vast majority of these important railroad rulers never even set foot in their namesakes.

Take, for example, William George Fargo. The New York native and capitalist founded the Wells, Fargo and Company Express, but he never saw the city that bears his name. But that doesn't mean he wasn't involved.

Before the railroad ever made its way west, Fargo and eleven other eastern financiers provided the funds for the Northern Pacific Railroad to be established. Once the city was created, Fargo himself offered $500 to establish the city's first newspaper, which was to be called the *Fargo Express*.[24]

Don't forget that Fargo wasn't always named for the wealthy transportation magnate. Originally called Centralia, the city consisted of a post office under the direction of Gordon Keeney and a small tent village. A telegram dated September 22, 1871, arrived from Thomas Canfield in New York City indicating the new city should be called "Fargo," and the telegram was delivered to the Post Office Department for approval of the name change, which it did on February 14, 1872. Yet "long before the post office department approved, however, the railroad, citizens, the press, and other governmental agencies had begun calling the place Fargo."[25]

William G. Fargo's story was typical for that time: born in 1818 in central New York to a poor family, he started working at an early age. Fargo had

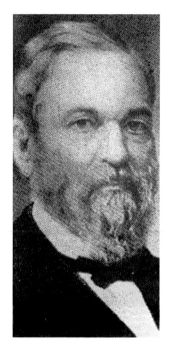

William Fargo was an influential financier who founded Wells Fargo. The city of Fargo is named for him. *From the* Forum of Fargo-Moorhead.

seven brothers and two sisters, and the boys were all expected to support themselves as soon as they were able.[26] By thirteen, he was riding horseback to deliver mail twice a week for a contract mail carrier based out of nearby Pompey. He and a few co-workers eventually grew the business into the express and banking company that still operates today as Wells Fargo. He'd amassed a sizeable fortune by 1867, when the Northern Pacific was a corporation with no startup money; Fargo and the eleven other financiers provided approximately $250,000 to the railroad, eventually serving as directors of the company.[27]

Fargo was descended from pioneers who settled in Connecticut in the seventeenth century, and his father was a sergeant in the War of 1812. These characteristics meant that "Mr. Fargo was well equipped by inheritance with the indomitable character and courage to cope with the difficulties of blazing of all new trails."[28] Fargo's company was localized to the Buffalo area at the beginning, but he quickly saw the need to expand.

Not everyone thought that way. Early in his career, Fargo worked with the Pomeroy & Co. express company. One of its owners, William Harnden, remarked that running a line far west of Albany wasn't of interest to him, saying, "If you choose to run an express to the Rocky mountains, you had better do it on your own account; I choose to run an express where there is business."[29] Fargo, Henry Wells and Daniel Dunning ended up forming Wells & Co. in 1844, which connected with the Pomeroy firm and extended the line from Cleveland westward to Detroit. Fargo was in charge of business operations as its executive and operating man.

Within a year, Wells and Dunning dropped their interests, so Fargo partnered with William A. Livingston. Fargo pressed his new colleague to push farther west, which "appealed strongly to [his] imagination and his tireless energy, resourcefulness and sound business judgment."[30]

By 1850, the American Express company was formed by the joining of several different companies, and Wells served as the first president (Fargo

eventually succeeded him). Within two years, he and Fargo formed Wells Fargo and Company with the intention of running an express to deliver packages and mail between New York and San Francisco by way of Panama. "Wells-Fargo's pony express was the sole link between many frontier towns and that their residents had known before migration. Banks, established in the West by this company, filled, dependably, a need of primary importance to successful gold miners."

As Fargo's business grew, so did his influence with the railroad companies. He served as director and vice-president of the New York Central and a large holder and director in the Northern Pacific.[31] He and Wells "became leading figures in all the communities linking the East and West. Many of the towns adopted names of the business figures."[32]

BUFFALO'S GREAT MAN

Fargo's contributions to his namesake city are important as "the thriving city of Fargo perpetuates the sterling qualities of its namesake," but he was also a significant citizen of Buffalo for the forty years he lived there. Fargo was never too busy to help promote the city on various civic projects, and he is counted among its most distinguished citizens, a list that includes Presidents Millard Fillmore and Grover Cleveland. "Mr. Fargo was chiefly a Man's man and cared little or nothing for the lighter side of social life and he despised insincerity and display. The people of his hometown knew him to be a broadminded man of the world and they likewise knew him as their neighbor and friend."[33]

Fargo served as mayor of Buffalo during the tumultuous years of the Civil War, working to ensure the city supported President Abraham Lincoln's efforts to end slavery. Fargo also made sure that every employee of his who enlisted in the Union army continued to receive his wages. His generosity extended to other cities as well; in 1871, Fargo gave $10,000 to help the homeless in Chicago who were devastated by the great fire.

Fargo was able to give away great sums of money thanks to his runaway successful business. By 1860, both Wells and Fargo were "already rich beyond the fondest dreams" either could have entertained.[34] That's when Fargo started setting aside money to build a beautiful home and possibly purchase the *Buffalo Courier* newspaper.

In 1868, Fargo purchased more than five acres of land in what was then rural Buffalo and built a grand mansion in the center of the grounds; when

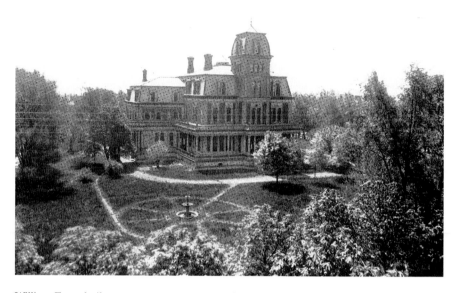

William Fargo built an enormous mansion in Buffalo, New York. After he and his wife died, the estate fell into disrepair and was demolished in 1900. *From* Western New York Heritage Magazine.

completed in 1872, the more than twenty-two-thousand-square-foot home was immediately dubbed the finest in the city. The mansion cost $600,000 to build, with another $100,000 spent to furnish it.[35] Fargo requested that his builder include wood from every state in the Union in the home. Grover Cleveland and Mark Twain were frequent guests.[36]

> *Most of the interior was in walnut. The broad, walnut staircase was impressive. It was rarely used, for the Fargo home had the first elevator ever installed in a home in this city....The house was surrounded by spacious lawns and gardens. One of the city's earliest private greenhouses kept the mansion supplied with fresh flowers throughout the winter.[37]*

Additionally, the home featured its own barbershop and stages in the dining room to accommodate musical acts invited to entertain the family or guests during dinner. The grounds included a separate building for the stables and an L-shaped private conservatory, one of the first in the country.[38]

Fargo and his wife, Anna, had five children, and his brother Jerome lived in Buffalo as well. "The two families shared most of their recreations. Sunday afternoons they gathered, with Grover Cleveland and other

old friends, in the famed Fargo drawing room, for hours of music and cultured conversation."[39]

Fargo died in 1881 at the age of sixty-four, prompting newspapers across the country to laud his many accomplishments. The *Daily Argus* in Fargo praised him, noting that he was "worthy of fame as an illustration of the heights of a position and affluence to which any young American with a cool head, brave heart, and strong hands may aspire to."[40]

His wife died just nine years later, and their two surviving children lived elsewhere. The enormous mansion in Buffalo sat empty for a decade, with no buyer interested in taking on the home. Fargo's mansion was razed in 1900 to make room for a subdivision of smaller homes. The home's "shed"—which provided servants' quarters and storage—was demolished in the 1960s to make room for a parking ramp.[41] In December 2015, the Fargo Estate neighborhood was approved as a national historic district.

In 1958, the City of Fargo contemplated placing a statue of its namesake in the Civic Center. Discussion about how to raise the money and whether a man who was never in the city should be honored in such a way ensued, and ultimately, the statue was never placed.

Chapter 3

GEORGE CASS

Fargo is located in Cass County, another name that hearkens back to the city's founding by eastern railroad magnates. George Washington Cass was born in Ohio in 1810 and enrolled in the West Point Military Academy from 1827 to 1832. He resigned from military duty in 1836 and entered civilian engineering work, serving as president of the Adams Express Company before going to work for the railroads.[42] By 1856, he was elected president of the Ohio and Pennsylvania Railroad Company.

In 1867, Cass became a director for the Northern Pacific Railroad, serving as president of the construction project from 1872 to 1875. He took over the railroad company at a tenuous time; the failure of Jay Cooke Company and the Panic of 1873 caused widespread financial trouble, and Cass's tenure ended when the railroad filed bankruptcy in 1875. The company was later reorganized in 1878, but Cass had moved on by that time. He got involved with politics, running for governor of the state of Pennsylvania in 1863 and 1868.[43] He was also a devout Episcopalian who held various offices within his church and gave generously to it. Cass died in New York City in 1888.

When the county surrounding Fargo, North Dakota, was established on January 4, 1873, it was named for George Cass, the NP Railroad president at the time. Cass County is not the only bearer of George Cass's name; Casselton—originally called Casstown when a Northern Pacific Railway station was established there in 1876—was also named for the railroad president. The city of Casselton was incorporated in 1880 with 376 people calling it home.

Additionally, though it never bore his name, Cass and his railroad colleague Benjamin Cheney traded railroad stock for ten thousand acres near Casselton to create an enormous farm; they hired Oliver Dalrymple to run the operation, bringing to life bonanza farming in North Dakota.

If it weren't for the railroads, Fargo wouldn't exist, but railroads didn't operate on their own. James J. Hill and James B. Power are names synonymous with railroad operations, and each played a major role in Fargo's founding.

Chapter 4

JAMES JEROME HILL

James Hill was born in Ontario, Canada, in 1838 to Irish immigrant parents; Hill's father died when the boy was just fourteen, so he went to work as a clerk to help his family make ends meet. At seventeen, Hill began working for the St. Paul levee, a move that led to his eventual purchase of the St. Paul and Pacific Railroad more than twenty years later.

By 1869, he had organized his company, Hill, Griggs and Co., and Hill started looking into steamboat transit on the Red River and Red Lake River. Hill secured a position as station agent for the St. Paul and Pacific Railroad but under a contract to handle traffic per ton; he negotiated a deal to exclusively provide wood (the only fuel available at the time) to the cities in northern Minnesota at a "given rate per cord," essentially putting "the entire fuel business of the city at his command."[44] To Hill's credit, he didn't exploit his power and governed the fuel business with fairness and moderation, and he quickly worked to extend the venture.

His familiarity with the river business on the Mississippi led him to engage in traffic for himself on the Red River of the North, through which he not only grasped the trade of Northern Minnesota with its sparse population, but also tapped that of Winnipeg and Northern Canada. Starting with one steamer, he made such success that in 1872 he consolidated his Red River interests with those of the late Norman W. Kittson, who represented the great Hudson's Bay Company, and formed the Red River Transportation Company, and before the railroads relegated navigation on the Red River

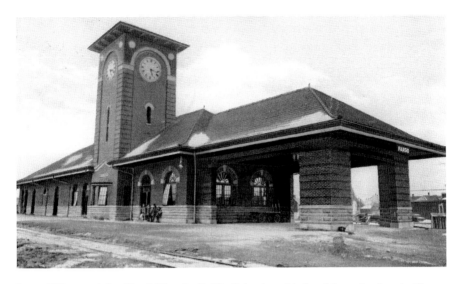

James Hill earned the title of "Empire Builder" thanks to his foresight to develop the Great Northern Railway. *Institute for Regional Studies, NDSU, Fargo.*

of the North to the past, he had no less than seven steamers and fifteen barges in his fleet. He was the manager and moving spirit in the Red River Transportation Company until the business was abandoned owing to the building on the railroads.[45]

But he saw potential for the railroad and wanted to reorganize the St. Paul and Pacific Railroad branch lines to reach farther west. The railroad reached northern Dakota in October 1871 by way of Breckenridge (nearly sixty miles south of Fargo-Moorhead), and the Northern Pacific line made it to Moorhead by December. The first NP train arrived in Fargo on June 6, 1872.[46]

Hill and two Canadian business associates purchased the St. Paul line in 1879, as well as sixty-five thousand acres of land on the Dakota side of the Red River Valley. The previous railroad owners had not developed the land, but settlers had been allowed to settle on the land.

The St. Paul, Minneapolis and Manitoba Railroad (later renamed Great Northern Railroad) was organized in May 1879, just as bonanza farming began taking off. Hill was the first general manager and "devoted his wonderful energies and vitality to the direct operating affairs of the railroad."[47] The line had already been connected to the Canadian border, and Hill used the capital to begin expanding the line to the west from Grand Forks.

The need for an extensive railroad system prompted both the Northern Pacific and St. Paul Railroads to begin a building frenzy, with a tenuous agreement in 1882 that the NP would get the east and west business and the St. Paul line would receive the north and south traffic.[48]

INFLUENCE AND SUCCESS

Hill's successful railroad business flourished, and he channeled that success into other ventures—specifically, Major Alanson Edwards's new *Daily Argus* newspaper. Hill financed the publication, but the goodwill didn't last that long. During the early 1880s, union railroad workers decided to strike the Great Northern Railroad in response to wage cuts. Edwards took their side, opposing the consolidation of various railroad lines. Hill resented Edwards's support, but he didn't pull back on his financial obligations. Hill unsuccessfully lobbied President Grover Cleveland for federal troops and eventually accepted an arbitration board recommendation and established a wage schedule for the workers.[49]

Then in 1886, the *Argus* building suffered severe losses due to a fire, and when Edwards's plans to rebuild fell through, Hill got nervous. He decided to foreclose on the Major and replaced him with Minneapolis editor George K. Shaw.

Another component of Hill's influence in the Fargo-Moorhead community stemmed from his friendship with Samuel Comstock, who served as a state representative in the Minnesota legislature for years.

> *Just what kind of relationship there was between Hill and Comstock is not certain from records that exist. However, in 1875, Hill began urging the Minnesota Legislature to grant him a charter for his Great Northern Railway, known then as the St. Paul, Minneapolis and Manitoba Railway. Comstock led the movement in the legislature in favor of Hill's plan. Comstock's efforts were successful. In return for the favor, Hill told Comstock he could locate and acquire townsites all along the new road.*[50]

Even though Hill wielded great influence in the Fargo community, he didn't live there. In 1867, Hill married Mary Theresa Mehegan and raised ten children with her in St. Paul, Minnesota. Their first home was a small cottage in the downtown area, but he eventually tore it down five years later to build a larger one.[51] As his wealth grew, so did his aspirations for a home

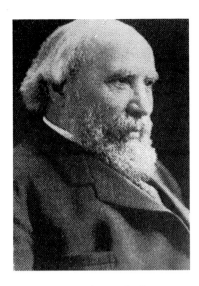

James J. Hill's influence in the transportation world was so great that he became known as the "Empire Builder." *From the* Forum of Fargo-Moorhead.

to match. He acquired several lots on Summit Avenue and had plans drawn up for a grand home overlooking the city of St. Paul. After four years of construction, the completed home included forty-two rooms, thirteen bathrooms and twenty-two fireplaces with a total of thirty-six thousand square feet of living space.

Hill's enormous home reflected "his experiences in the business world as well as his own tastes and preferences."[52] At the turn of the twentieth century, Hill counted among his friends some of the most prominent men in the country, including financier William Vanderbilt, industrialist William Rockefeller, banker J. Pierpont Morgan and railroad promoter Henry Villard. That home housed the Hill children and served as a center for both their public and private lives. Four daughters got married in the home's large drawing room, and some of the newlyweds lived there until their own homes on Summit Avenue were completed.[53]

THE EMPIRE BUILDER FALLS

Hill's later years weren't quite as jubilant as the previous decades had been. He began buying smaller railroad lines in the late 1890s, and eventually Hill teamed up with Morgan to buy controlling interest in the Northern Pacific Railroad. E.H. Harriman contested the purchase, instead partnering with the two giants to create the Northern Securities Company. The new organization would control the Great Northern, Northern Pacific and Burlington lines but was wildly unpopular and in violation of Minnesota statutes.[54]

In 1902, President Theodore Roosevelt prosecuted Hill's company under the Sherman Antitrust Act. The case made it to the U.S. Supreme Court, which ruled against the company in a 5 to 4 decision. The bitter blow was the first sign that the federal government would begin taking a role in keeping corporate monopolies at bay in the twentieth century.

Hill rebounded and focused his business interests elsewhere. In 1907, he became chairman of the Great Northern board. Five years later, he retired, handing the reins over to his son Louis. In May 1916, Hill contracted an infection that spread quickly. Doctors could not stop the spread, and Hill slipped into a coma and died at the age of seventy-seven. He was mourned greatly.

At the hour of his funeral, business stood still and every head in North Dakota and Minnesota bowed in silence or in prayer out of regard for this truly great man. Business houses closed, railroad trains stopped wherever they happened to be; teams stopped on the highway; plows ceased to move in the furrow and the hand of the seeder was stayed while all hearts went out and up for him who had been their friend, and who was now gone from earth's activities. [55]

The nickname "Empire Builder" is truly fitting for Hill. His vision and drive expanded an area of the country that people had previously believed could never be developed.

The states of Minnesota and the Dakotas became popular states for immigration because of Hill. The small town of Seattle, Washington became an international shipping port. America was linked with an excellent railroad network which encouraged rapid growth. Where other railroad builders were searching for ways to get every cent possible, Hill was surveying the land himself, looking to create the most efficient railroad network.

Mary Hill continued to live in the grand mansion until she died in 1921. The home ended up being gifted to the Catholic Archdiocese of St. Paul, which used the house as an office, school and residence. In 1978, the Minnesota Historical Society acquired the property, which is now in the National Register of Historic Places. Tours are given of the historic home.

Hill's children continued to pursue worthwhile ventures. Three of his daughters built a church called St. Mary's of the Lake Catholic Church in White Bear Lake, Minnesota, to honor their mother; they provided the funds to construct a building that was a replica of the St. Mary's Church where their mother had worshiped in St. Paul. His son, Louis Hill, succeeded his father in running the railroad; he was also largely responsible for the creation of Glacier National Park.

Chapter 5

JAMES B. POWER

Just as James Hill's name is synonymous with what became the Great Northern Railroad, James Buel Power's is with the Northern Pacific Railroad. Power was born in Hudson, New York, in 1833 and parlayed his loved of mathematics into a college degree in civil engineering. He landed a job as a railroad surveyor, working as such for several years.

In 1856, Power accepted a position as "civil engineer in charge of work on the Susquehanna division of the N.Y. & Erie Ry, but the east was too slow for his young blood,"[56] so he headed to Minnesota to work as the chief clerk in the state's land department. In 1861, Power was appointed deputy state treasurer, a post he held for four years before moving to the U.S. surveyor general's office. He eventually found employment with the Northern Pacific Railroad, which had been created in July 1864. The land office was originally opened in New York, but the railroad moved it to St. Paul to handle the influx of immigrants. He achieved the position of land commissioner in 1873, a tumultuous time in the company's—and the country's—history.

While great effort was made to advertise the opportunities that would accompany transcontinental access, funding for the project was of utmost importance. Yet people were reluctant to spend their money financing that which wasn't yet built.

The people knew that it would be many years before the railroad would be completed and earning money, and they were not sure that it would ever be a success. They were rather afraid of losing their money in such a scheme. To

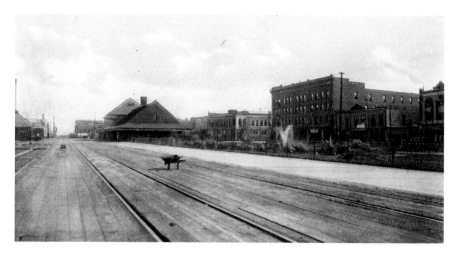

Above: The Northern Pacific Railroad reached Fargo in June 1872. The depot was built in 1898 and today houses the Fargo Park District. *Institute for Regional Studies, NDSU, Fargo.*

Left: James B. Power worked as a land agent for the Northern Pacific Railroad and was instrumental in bringing bonanza farms to North Dakota. *From the* Forum of Fargo-Moorhead.

overcome this fear, the company agreed to give each stockholder an amount of land equal to the value of his stock in case the company should fail. In this way the confidence of the people was secured and millions of dollars were raised to begin the work. Millions more were loaned to the railroad company by Jay Cooke & Co., bankers, of Philadelphia. [57]

That particular business deal ended in disaster because in 1873, the Jay Cooke Company and the railroad went bankrupt, causing a widespread national panic. Out of that panic, though, rose a new opportunity. Men who owned significant stocks in the railroad exchanged land for them, often

securing large tracts of land. That opportunity inspired Power to consider the possibility of bonanza farms, and he began promoting it. His ardent support of the bonanza venture earned him the nickname of "the father of North Dakota agriculture."[58] "Power was not only the originator of the bonanza idea, but was important in the development of the livestock industry, new seeds, and other innovations in the State's agriculture."[59]

Power himself convinced several eastern investors to purchase parcels of land ranging from eleven thousand to sixty-three thousand acres (at the time, the average American farm size was less than one hundred acres). Power purchased several thousand acres himself (he never revealed exactly how many) and set up a comfortable cattle operation called Helendale south of the Red River Valley.[60] In the spring of 1877, Power described his success at promoting the Red River Valley and enticing many farmers to the area:

> *Power and the Northern Pacific officials hoped that the bonanza farms would serve as the basis of a great promotional campaign to dramatize the potential of the area. But in their expectations they had not counted on the many wild stories about the bonanza farms that were written or passed by word of mouth to other parts of the country.*[61]

The NP Railroad reorganized in 1879, and Power left the company just three years later, taking a position with the St. Paul, Minneapolis and Manitoba line (which became the Great Northern Railroad), but only until 1886, when he retired to his farm in Richland County.

Power ended up serving on the first Board of Trustees of North Dakota Agricultural College (NDAC), but his position was not without tension. Because of his influential role with the railroad and as a bonanza farmer, Power was accused of using the college as a market for his farm products. He was removed from the board but continued to profess his innocence and sued. The court ruled that he could retain his board position through the end of his term, even serving as acting president from 1893 to 1895, when he was replaced by John Worst. Power also served as a member of the state House of Representatives in 1897 and became a pioneer breeder of purebred cattle in North Dakota.[62] He died in 1913 at the age of eighty.

A lasting memorial to his work is Fargo's Island Park; Power convinced the NP Railroad directors to donate that choice piece of real estate in the heart of Fargo to the city itself.

Part III
Battle of the Bonanzas

Chapter 6

THE BIRTH OF BONANZA FARMING

It's no secret that agriculture is the industry du jour in North Dakota, and that's been true for longer than the state has been a member of the American Union. But the extent to which farming has changed over the last 127 years cannot be described succinctly. One of the most significant changes is the size of the operations.

When the Great Northern and Northern Pacific Railroads made it to North Dakota in 1871, opportunity abounded. The companies enticed eastern financiers to purchase stocks, which were backed with a promise of land should something happen.

Something happened.

After being approached twice, Jay Cooke reluctantly agreed to supply construction funds and sell NP stocks because he thought the investment was solid, despite his initial reservations. The company ended up over-extending itself regarding its railroad bonds and couldn't meet its commitments; on September 18, 1873, the Jay Cooke Company shut its doors and declared bankruptcy, simultaneously bankrupting the railroads it funded. A national panic ensued. Stockholders cashed in their stocks for land, and any other railroad land sold for pennies an acre.

Thus, the bonanza farm was born. In the decades that followed, a handful of successful bonanza farms—named using a Spanish word meaning "good weather" to symbolize the sudden wealth that accompanied the operations[63]—emerged in the lush Red River Valley. Two of those farms rose above the rest, not just in terms of size but also the influence each

had on the community surrounding them. Oliver Dalrymple and Herbert Chaffee were the managers of those massive farming operations, and their stories are the stuff of which North Dakota legends are made.

It's interesting to consider that the coming of the railroad provided the jumpstart for the founding of Fargo as a thriving community and also that that same railroad's failure in 1873 prompted a prosperity Fargo and the state of North Dakota had never seen before.

"It is a singular fact that this great failure, so depressing and so discouraging to all connected with the Northern Pacific, was the true cause of the prosperity which followed," James B. Power said in a newspaper article. "But for this growth the country would have been slow, the land would have passed into the hands of speculators, and many of the evils which the people talk of in connection with the large grants of land would have followed. It would have been easy to have placed the lands in the hands of speculators: to have wiped out more of the bonds, but that would have left the country undeveloped and the road without revenues.... The most rapid development ever known in the world followed that one venture, and Fargo was in the very center of this great activity."[64]

Some of the first North Dakota stockholders to take advantage of the financially crippled company were brothers John and William Grandin, along with George Cass and Benjamin Cheney, at the extreme urging of James Power. He enticed them with news that a homesteader near the Sheyenne River had produced a bumper crop of wheat that sold for $1.25 per bushel. Cass and Cheney were convinced and cashed their bonds. But not all of these men were going to run farming operations on their own. The Grandin brothers did, but Cass and Cheney immediately set out to find someone who could manage an enormous farm.

That man was Oliver Dalrymple.

Dalrymple already had a reputation for farming when Cass and Cheney came calling. He'd become known as the Minnesota wheat king after setting up a large operation near Cottage Grove, Minnesota. He was actually a lawyer who had attended Yale in the 1850s and ended up in St. Peter, Minnesota, in 1856 to practice law. Heeding the advice of one of his Yale classmates, Dalrymple moved to St. Paul and ended up settling claims of settlers who had lost land in the 1862 Indian attacks.[65]

In 1860, he was offered a job in Judge Charles Flandrau's office, and just three years later, he became a partner of the firm with Flandrau and

Oliver Dalrymple was one of the most successful bonanza farmers in North Dakota. *From the* Forum of Fargo-Moorhead.

another lawyer. Using the $40,000 he earned from that job, Dalrymple bought a three-thousand-acre farm and cultivated wheat successfully until 1874, when he ended up on the brink of bankruptcy thanks to bad grain trade activity. As he was contemplating his next move, James Power came calling on behalf of Cass and Cheney because Dalrymple's extensive experience surpassed the mere fact that he lacked capital. He was offered the opportunity to farm the land Cass and Cheney acquired from the NP. Dalrymple knew the opportunity was a gamble, so he insisted on seeing the land first and took soil samples back to St. Paul with him. He liked what he saw, so he borrowed $50 to travel to New York and make the deal with Cass and Cheney official.

Dalrymple came back to St. Paul, packed up his family and moved to Dakota Territory, building the first home between Fargo and Bismarck and planting his first crop in 1874. Two years later, he harvested thirty-two thousand acres of wheat, and it was dubbed the crop that was heard of 'round the world.[66]

The NP Railroad decided to capitalize on his success with a major advertising campaign across the globe touting the wealth of the Dakota Territory and its cash crop: wheat. The railroad was able to turn its financial situation around as new residents came west to purchase its lands, allowing the railroad to reorganize in 1879.

When Cass and Cheney set out to find a manager for their massive farming operation, they didn't realize he would become so closely associated with the farm that it became known as the Dalrymple bonanza from nearly the beginning of its existence. All told, Dalrymple ended up with approximately 100,000 acres to manage, with nearly 65,000 acres of that dedicated to wheat. He divided the operation into 2,000-acre sections and set up each with a superintendent and foreman to manage as its own entity.

Each estate had suitable and complete buildings, consisting of houses for superintendent and men, stables, granaries, tool-houses, and other buildings.

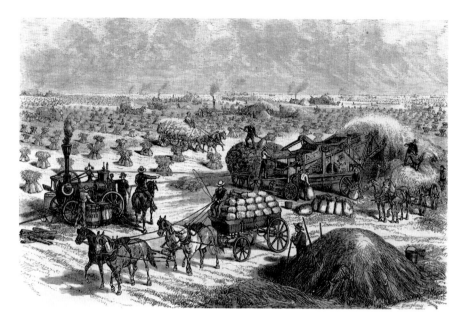

A postcard from 1878 shows a panoramic view of several threshing machines at work in a Dalrymple farm field covered with shocks of wheat. *Institute for Regional Studies, NDSU, Fargo (Folio 102.AgB66.3).*

As a matter of course, to carry on the Dalrymple farm required the services of a large number of men and horses, the use of many plows, harrows, seeders, harvesters, threshers and engines, wagons, and other implements and tools.[67]

Back in 1869, when Dalrymple had returned to Pennsylvania for his father Clark's funeral, he met twins named Mary and Martha Steward from New York. Apparently, the tall, bearded Dalrymple was struck by Mary's curly red hair, and he became immediately smitten. He proposed marriage in the fall of 1870, writing that he was excited about her acceptance of his proposal, and promised that she would be "given a house where love may make up for inconveniences and deficiencies."[68] The pair married in March 1871 when Dalrymple had a break in his farming schedule; they were wed in Cottage Grove and traveled to St. Paul afterward.

Within the next couple of years, two sons were added to the family: William Ferguson and John Stewart. Mary was an active and popular member of the St. Paul community, which had a population of about twenty-five thousand people at the time. After living in a smaller home

on College Street, the Dalrymple family moved into a larger home on the fashionable Summit Avenue. She organized a euchre club and served on the board of St. Luke's Hospital.

The youngest Dalrymple son recalls fond memories from the bonanza farm life, from his father riding horseback every day wearing his tall Stetson hat to gathering around bonfires with the one-thousand-men threshing crew. Even though Dalrymple never shot a gun, he allowed his sons to train two hunting dogs named Spot and Sport.

One thing was consistent across all bonanza farms: the cook was the most important person. Feeding the men well was important on a bonanza; in fact, food represented the largest expense after wages.[69] "If the men were dissatisfied with their food they either rioted or wandered off. It wasn't easy to make a tempting meal out of salt meat, pork and beans, corn meal, dried apples, codfish and prunes, beans, beans, beans, and more beans."[70]

Of the several bonanza farms that emerged in the late 1880s, none—including the Dalrymple farm—was quite as impressive as the Amenia and Sharon Land Company operation. "While not the best known bonanza, the Amenia and Sharon in many respects was the greatest of them all. Its success was due to a great extent to the father-son team of E.W. and H.F. Chaffee. Their progressive, forward-looking policies created a multi-million dollar organization."[71]

The farm came into existence in 1875 when forty stockholders purchased more than twenty-seven thousand acres of NP land. These weren't wealthy financiers, though; this group of New Englanders were simply middle-class

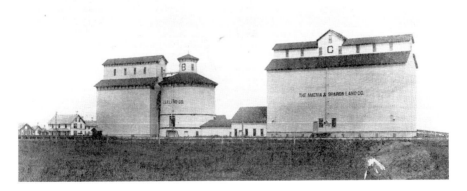

Amenia and Sharon Land Company elevators were built along the railroad tracks to handle the company's large wheat harvests. *Institute for Regional Studies, NDSU, Fargo (Folio 102AgG46.2a).*

citizens whose investment in the railroad was too important to lose. The individuals lived in Amenia, New York, and Sharon, Connecticut, which is why the company was named the Amenia and Sharon Land Company when it was incorporated in July 1875.

One of the largest shareholders of the company was Eben W. Chaffee, who became director of the company. He set out for Dakota Territory to choose the land and set up operations. The group had little choice— they'd believed that investing in the Northern Pacific Railroad would provide a safe and profitable return, making the failure of the Jay Cooke Company and, subsequently, the railroad so troublesome for the stockholders. Chaffee headed west to meet with James Power, the NP land agent at the time.

Because most easterners thought the company and railroad failed because the land was worthless, the group originally wanted Chaffee to select land that would be developed and then sold off, but Chaffee immediately realized the potential of the Red River Valley soil. He clandestinely hired a professional sodbuster and a foreman, increasing wheat production from 640 acres to 2,200 acres within two years.[72] The operation continued to expand, and favorable rains resulted in great yields, making stockholders wealthy individuals back east.

> *Eventually the Amenia and Sharon came to own over thirty subsidiary farming, elevator, livestock, and finance enterprises. It also owned two towns and at one time a railroad. It actually had over 42,000 acres under cultivation at its peak which very likely meant that it was the largest bonanza in that respect since Dalrymple's maximum acreage under cultivation cannot be positively established.*[73]

Chaffee, North Dakota, was named for the company's director when it was built around an elevator in 1893. Amenia was named for Chaffee's hometown in New York, and the city quickly materialized as soon as the company's elevator was erected; the city's hotel became the "center of social life during the days of the old land company."[74]

When the Amenia and Sharon Land Company was originally created, E.W. Chaffee was only spending his summers in Dakota Territory and traveling back to Connecticut in the fall; he'd return to North Dakota by April 1. By 1886, he and his wife had established permanent residency in Amenia, North Dakota. He and his wife, Amanda Fuller, were New Englanders through and through. Both could trace their family roots

back to the Plymouth colony; before they moved to North Dakota full time, both Eben's mother and Amanda's mother lived with the family along with the two Chaffee children, Florence[75] and Herbert Fuller, aka Bert or H.F.

Not only was Chaffee a successful farm manager, but he also served at the North Dakota Constitutional Convention in Bismarck in 1889 and helped form a Congregational church in his new community. Chaffee served as the church's treasurer and left a house for its parsonage in his will; during his tenure as farm manager, he practiced his religion by not allowing work on Sundays. At one point, he also served as justice of the peace and was a strong prohibitionist. He was a man known for his unwavering integrity and honesty.

As farm manager, Chaffee expanded his personal wealth through strategic land purchases. He also added company stock to his holdings whenever possible, ending up with more than 528 shares of the 994 at the time of his death. He was also an astute businessman who realized that financing renters and contract buyers on the company's land would produce a new revenue stream for the already successful company.[76]

By 1892, E.W. Chaffee's health was failing, so he resigned his position with the land company. His son H.F. Chaffee and a nephew, James S. Chaffee, took over. E.W. Chaffee died on October 19, 1892, on his way back home from Hunter, North Dakota. Tension was already mounting between the two groups of stockholders—those in the East who wanted to liquidate the enormous farm and those in the West (primarily Chaffee family members) who wanted to continue developing the bonanza. When Chaffee resigned, the easterners saw an opening to install their own representative as leader, which is how James S. Chaffee entered the picture.

However, E.W.'s son H.F. Chaffee convinced James not to sell out and instead offered him a leadership position. E.W. and H.F. Chaffee had previously hatched a plan with Frank Lynch, a Casselton implement dealer and local financier, to build a railroad through the company's lands, yet both the Northern Pacific and Great Northern declined to extend a branch. By 1893, H.F. Chaffee and Lynch were pushing forward on the railroad idea despite strong opposition from the eastern faction; they ended up forcing a legal battle, hoping the easterners would back off. They didn't. Instead, they decided to withdraw land equal to the amount of stock they held and create a new company.[77]

As plans moved forward for the branch line, tensions mounted. On October 13, 1893, Lynch resigned his involvement with the company, and

on July 30, 1895, E.W. Chaffee's family incorporated a new business called the Red River Valley Land and Investment Company; later, his descendants would organize other businesses such as the Wanotau Land Company and the Chaffee-Miller Land Company.

While E.W. was a good farm manager, his son H.F. Chaffee was a great one—perhaps even a managing genius of bonanza farms.[78] From a very young age, H.F. Chaffee was meticulous about managing his money, even tracking pennies spent on candy. H.F. Chaffee also logged his spending on his honeymoon to Hawaii.

> *From 1893 to 1912 he built the Amenia and Sharon Land Company into a million-dollar organization when older bonanzas were liquidating rapidly. The net assets of the company far exceeded those of any of the other bonanzas. Chaffee was the man most responsible for building a great and durable financial empire.*[79]

H.F. Chaffee was educated on the East Coast, in seminaries as well as a science school. He visited Oberlin College in Ohio and met his future wife, Carrie Constance Toogood of Iowa. He married her on December 21, 1887.

H.F. Chaffee became such a successful manager in part because his father constantly delegated responsibility to him. When E.W. went back east, H.F. Chaffee was left in charge of everything—finances, personnel, buying and selling crop. After E.W. resigned, H.F. Chaffee became superintendent when his cousin James (then acting manager who preferred the East Coast) delegated the responsibility to him. Once the company split, H.F. became general manager.

H.F. Chaffee continued to find success as he grew the family business, but that success would come to a screeching halt in April 1912. H.F. Chaffee and his wife boarded a ship, but only Carrie Chaffee returned. Even as Carrie boarded the lifeboat, she didn't realize the gravity of the situation or that within a few hours, the luxury liner known as *Titanic* would be sinking to the ocean floor. "But as the small boat pulled away from the doomed ship, she recognized the source of the low purring sound. 'It was the water rushing into the *Titanic*'s side, and my heart seemed to stop,' the Amenia, North Dakota woman later told news reporters. 'The great vessel was perceptibly lowering in the water.'"[80]

H.F. Chaffee was only forty-seven when he died, and he left behind his widow, five children and a business worth millions. After H.F. Chaffee's

Herbert Fuller Chaffee and his wife, Carrie, had two children, Florence and Lester. *Institute for Regional Studies, NDSU, Fargo (rs007127).*

death, the Amenia and Sharon Land Company could not continue operating. Even his son H.L. Chaffee acknowledged the lack of decisive leadership and too many family politics. Members of the family tried to operate the business without H.F. Chaffee, but to no avail. The Amenia and Sharon Land Company was finally subdivided in 1923.

PROMOTER VERSUS PRAGMATIST

Both Dalrymple and Chaffee were exceptional bonanza farm managers, though Dalrymple seems to have overshadowed Chaffee in terms of notoriety regarding their operations. Yet Chaffee was likely more organized and effective when it came to his management style.

> *Oliver Dalrymple, the Minnesota Wheat King, who became the best known of all the bonanza managers (his name is synonymous with bonanza because of the wide publicity about his enterprises); H.F. Chaffee, the real king of the bonanza managers although his life was prematurely ended in his early forties. H.F. Chaffee had not only pyramided his holdings but also built a very sound financial structure under these holdings. His leadership enabled the Amenia and Sharon Land Company to remain in business as a bonanza operation longer than any of the other great farms.*[81]

Dalrymple's downfall really came down to record-keeping—something he wasn't especially good at. He even ended up in a tiff with Power over the situation.

> *Dalrymple was primarily a plunger and speculator. His son, John S. Dalrymple, said that his father was interested in pyramiding his holdings without too much concern about the amortization of the land. Dalrymple counted on time and rising land prices and so proved to be a shrewd prophet of what was to happen in North Dakota agriculture.*[82]

Power was a thorough and meticulous manager; he wasn't a fan of Dalrymple's careless record-keeping habits. Power, as NP land director, began corresponding with Cass and Cheney regarding his concern about the records. Power set up a system for the Dalrymple farm, but the farmer couldn't keep up with the records, so Cass and Cheney made Power both cashier and accountant in 1877. The change didn't sit well with Dalrymple.

Power continued to pressure Dalrymple about expenditures for the operation, and by the end of the year, Cass and Cheney wanted a new financial manager; Power encouraged finding someone outside of the operation. Dalrymple had a hard time with the new accountant, and tensions reached a zenith in 1878 when Dalrymple overdrew Cheney's account by $1,800 but had no explanation for the oversight. In December,

Cass and Cheney requested that Dalrymple come to the East Coast to figure out the situation, but he couldn't afford the trip, so Power covered the cost.[83] The owners and their manager came to a new agreement that restricted Dalrymple's influence but also removed Power from the situation.

Despite those earlier conflicts, Dalrymple turned the bonanza farm into a success. Just two years after starting, he brought in nearly $50,000 in capital investment and lost only about $1,400; he was rewarded with a share in the operation worth about $10,000. He continued to operate the farm successfully until one September evening in 1908 when he came in, exhausted. His son John pulled up a chair next to his father on the porch and started talking about the day's work; his father never answered him. Oliver Dalrymple died at the age of seventy-eight.

In 1896, the Cass-Dalrymple partnership dissolved, so Dalrymple divided the farm into ten units. When Dalrymple died in 1908, his sons operated the farm until 1917, when they realized interest returns would yield more than the profits from farming. The Dalrymple bonanza was sold in 1917.

LEGACY LEFT BEHIND

The NP Railroad could not have made a better decision than to exchange land for its stock (not that many other decisions were even possible when the company went bankrupt in 1875). In three years, the company sold 70 percent of its land to stockholders, with nearly half of more than 1.2 million acres transferred to just forty people.[84]

Bonanza farming emerged at exactly the right moment in modern history.

> *They introduced a new style of frontier agriculture, copying the techniques of the rapidly growing American industrial economy. The construction of a vast railroad network and the simultaneous increased European demand for American agricultural products provided the necessary stimulus for rapid settlement of the Red River Valley and cultivation of its fertile land. The bonanzas by their very size were the source of many legends [and] stories which were circulated in magazines and other various publications through the country in the 1880s and after.[85]*

Thanks to the bonanza farms, the population of North Dakota boomed. In 1870, twelve counties counted about 1,000 residents among them. Ten years later, 56,000 people called Dakota Territory home. By 1890, the

population was 166,000, and it grew to 350,000 by the turn of the century. The state itself changed as well.

As far as the eye could reach, a vast field of waving green shimmered in the sunlight, there was not a sign of living thing on the great unbroken plain.... It was open solitude, sweeping into unlimited space, the green blending into the blue of the western sky....It was more like looking out on a great, glimmering, emerald sea, than on a land that some day might be teeming with industries. Today, from the same point of view, we see the fine homes of prosperous farmers.... The silence of the first days is now broken by the click of the harvester, the hum of the threshing machine, the rustle of the corn leaves, the sound of school and church bells, the roar of the great trains on their way to the market laden with the produce of the farms, a grand moving picture of busy, pushing, progressive, prosperous life.[86]

The impact of bonanza farms cannot be understated—they changed the face of North Dakota with each stem of wheat gathered. "The magic wand with which the desert has been made to 'bloom and blossom as the rose' is 'wheat.' Here upon the heretofore bleak and arid plains of Dakota, this all-important cereal seems to have found its fittest abiding place, and here it is that it responds most plenteously to the manipulations of the husbandman."[87]

Even presidents weren't immune to the allure of the bonanza farm. President Rutherford Hayes was at the Minnesota State Fair in 1879 and decided to visit Dalrymple's operation.

"Mr. Dalrymple," said the President, "do you ever get tired of looking out over nothing but miles and miles of waving wheat?"
Oliver Dalrymple answered, "Does a sailor get tired of looking at the sea?"[88]

Hiram Drache, author of "The Day of the Bonanza" and local bonanza farm historian, says Dalrymple earned more notoriety as a bonanza farmer than H.F. Chaffee because Dalrymple was a natural promoter who had learned how to sell his product in Minnesota before picking up and moving to the Red River Valley. The Chaffee family who ran the Amenia and Sharon Land Company just weren't as interested in putting on a show like Dalrymple was.[89]

As for the Amenia and Sharon Land Company, its dissolution was inevitable after H.F. Chaffee perished on the *Titanic*. "When you lose a good leader, you always lose something," Drache said. Not to mention

that changing agriculture laws worked against the bonanzas; Drache said bonanza farms were often disliked because they enjoyed advantages that other businesses didn't.

> *The bonanza farmer is not liked by his quarter-section neighbors, and the reasons are plain to be seen. In the first place, the big farmer prevents neighbors coming in to make life pleasant for the settler; there is very little sociability on the prairies because the homes are too far apart and too difficult to access, especially in the six months of the winter season....The bonanza farmer is not a social animal with his neighbors. He leaves the country early in the fall along with the migratory birds and does not return until spring. The silent and almost deserted farm is left in charge of the foreman; the proprietor spends his winter somewhere else.*[90]

Bonanza farms had their day, but the success wouldn't last forever. Within the first decades of the twentieth century, bonanza farms were being broken up into more manageable—and profitable—operations. Power attributed the bonanza's downfall to five issues: diversification, lack of good management to result in profits, 1880s crop failures, labor problems and an interest in smaller operations. Taxation also created issues for bonanza farms, especially an operation like Amenia and Sharon Land Company, which dealt with corporation excess profit taxes, income taxes and real estate taxes.

Though bonanza farms eventually dissolved into smaller operations, they had a lasting and dramatic effect on North Dakota. The lure of golden wheat was strong, and many people streamed into the state seeking fortune and wealth. Those settlers didn't leave when bonanza farms dissolved; instead, they innovated and preserved, just as North Dakotans have always done.

Part IV
Big Business

ALANSON EDWARDS

The Mighty Major

F ew things that came to be in Fargo at the turn of the twentieth century don't have the fingerprint of Alanson Edwards on them. He was an imposing man—not just in size but in ability and interest as well. When Edwards died in 1908, many were left feeling bleak and lost, his only daughter, Marie Belknap, recalled in 1949.[91] Once the minister had finished the usual services, an itinerant preacher named Reverend William Edwards (no indication he was related to the deceased) asked to say a few words. And they were profound, Belknap remembered:

> *I have always wished I had his talk for it came from sincere and loving thoughts. In substance he told of Father, the man we knew and loved. He told of his brotherhood to his fellow man which was his religion and he told of his big heart as large as his body; of his sympathy and understanding to any in want or need. A few words and honest words, and words of deep affection and true admiration.*

Belknap said her son, Liscoe Edwards, who was about seven years old at the time, looked up at her and remarked in awe, "Why, Mother, my grandfather was a great man."

Indeed.

ALANSON'S STORY STARTS

Like many of the men responsible for jumpstarting a fledgling railroad station like Fargo, Edwards came to North Dakota by way of nearly every other state in the United States at the time. His story began in the northeastern corner of Ohio, in Lorrain County to be exact. That's where he was born on August 27, 1840, to Alonzo and Abigail (Trowbridge) Edwards.[92] His family trekked west soon after, landing in Macoupin County in Illinois just southwest of Springfield, where he went to primary school. When Edwards was eight years old, his father and a brother died; who took care of Edwards and his remaining brothers is unclear.

What we do know is that Edwards ended up at McKendree College (now McKendree University) from 1856 to 1857 in Lebanon, Illinois, though existing records do not indicate a course of study. With war looming on the horizon, Edwards became a railroad express agent and telegraph operator in Gillespie, Illinois.

When he volunteered for service in the Union army, Edwards was turned away because he weighed more than 250 pounds. He persisted, leveraging his rare ability to read and write as a way to help, so he wrote the muster roster (in his noted beautiful penmanship, no doubt). According to legend, he sneaked his own name on the roster,[93] and General Charles Ewing didn't realize it during roll call, but the story eventually came out and everyone had a good laugh. He enlisted in 1862 at the age of twenty-three once the war was in full swing; he was mustered into service on September 4, 1862, and trained at Camp Palmer in Carlinville, Illinois, with the 122nd Illinois Volunteer Infantry Regiment.

Edwards's illustrious war service provided the nickname he would come to be known by once he settled in Fargo. Edwards first served as a clerk in the office of the adjutant-general but quickly ascended the ranks, earning appointments as lieutenant and adjutant. Edwards marched with General William Sherman, supposedly on a horse because Edwards was so large. Apparently, Edwards didn't draw a ration for thirty-seven days but still gained fifty pounds.[94]

Sherman reassigned Edwards to duty as acting assistant adjutant-general of a different army corps division, where he served until the war ended. He earned the title of major on March 13, 1865, for his "gallant and meritorious service."[95] Even though that was the end of his army service, Edwards would be affectionately referred to as "The Major" for the rest of his life.

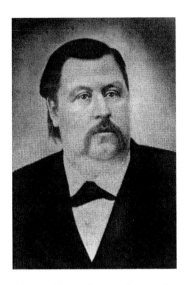

Alanson Edwards earned the rank of major while serving in the Civil War, and the title stuck with him the rest of his life. *From the* Forum of Fargo-Moorhead.

But that's getting ahead of the story. Once Edwards was mustered out of service in July 1865, he had to figure out what he would do next with his career. Using his knowledge from prewar times as a railroad express agent and operator, Edwards revived a newspaper—the *Union Gazette* at Bunker Hill, Illinois. Edwards had been publishing the newspaper when the war broke up but suspended its publication during his service.

Three years later, Edwards purchased interest in another local newspaper, the *Free Democrat* in Carlinville, Illinois. In Carlinville, Edwards met and married Elizabeth Robertson in 1870. Shortly after their wedding, Edwards's career took a strange turn. He became warden at the state penitentiary in Joliet, Illinois,[96] where his second child and only daughter, Marie, was born.

"It was a standing joke that it was quite alright [*sic*] to be born in such a place but care should be used that it was not also a place for dying," Marie was reported to have said.[97] Her younger brother, John, reflected in his own memories that "to add to her injury of being 'born in the pen,' it had to be on a Christmas eve, and Sis never has gotten over the tribulation of having her Christmas and birthday presents combined into one instead of the customary two."

ON THE MOVE

Edwards ended up making another significant career change after the great fire in Chicago wiped out much of the Windy City in 1871. He saw an opportunity to go into the insurance business, so he moved his young family to 194 Ashland Avenue in Chicago.[98] Edwards quickly worked his way up through the business community, landing a position as a member of the board of trade from 1875 to 1878.

During those years in Chicago, the Edwards family welcomed two more sons to the brood—William Robertson (Billie) and Alanson Charles

(Charley). That was also when "the pioneering bug had infected father," his son John remembered.

That's why Edwards didn't stay long in Chicago. By 1876, that "bug" meant the gold rush in the Black Hills of South Dakota beckoned Edwards. En route to the Black Hills, Edwards passed through Fargo, a "straggling village" at the time.[99] When the gold rush didn't pan out, Edwards headed back to Chicago but decided to spend two weeks in Fargo and quickly decided it would be his future home. (His last three sons, John Palmer, George Washington and Richford Roberts, would be born in Fargo.) Edwards was so impressed with Fargo and the possibility of the entire Red River Valley that he immediately inquired about the possibility of founding a newspaper there. At the time, Fargo had only one newspaper, the *Fargo Times*.

Back in Chicago, the Major approached Dr. J.B. Hall, a friend he knew was looking for a place to start a newspaper. Hall wasted no time, and by September, he and his family were in Fargo. In the meantime, others had

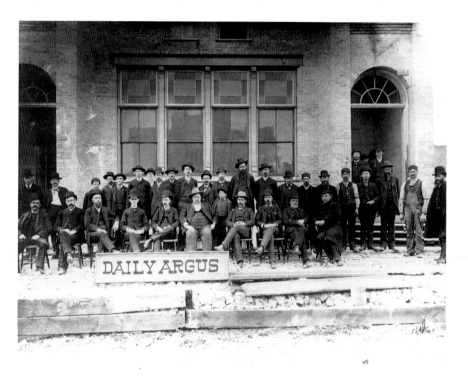

Major Alanson Edwards (*center*) founded the *Daily Argus* in Fargo in 1879 but was forced out by James Hill in 1891. *Institute for Regional Studies, NDSU, Fargo (2013.8.3).*

started the *Red River Valley Independent*, and Hall wrote Edwards that he did not think Fargo could support so many papers. "I wrote the doctor that I agreed with him, but to go ahead and start the *Republican*, and we would take our chances on the survival of the fittest," the Major replied.[100]

The *Republican* printed its first issue on September 25, 1878, but unfortunately, its owners couldn't get along. By 1879, Edwards offered Hall a deal: sell his interests or buy Edwards's. Hall agreed to buy out the Major.

Supposedly, Edwards agreed to stay out of the newspaper business, but just a month after leaving the *Republican* behind, Edwards traveled to St. Louis to purchase publishing equipment and then purchased a building in Chicago to house his publication. He had everything shipped to Fargo, set up in an office on Front Street (now Main Avenue), next to deLendrecie's store. By November 1879, Edwards had started publishing the *Daily Argus*. Shortly after, Edwards also created the Argus Printing Co. for printing promotions materials; he hired C.P. "Con" Walker to serve as foreman of the printing office.[101]

THE TALK OF THE TOWN

Edwards and his newspaper quickly became the talk of the town, even though he had arrived on the prairie a mere year earlier. "His generous physical proportions, his genial manners and his seductive smile attracted people at first sight...and he could number almost every citizen of the little village as his friend," remembered George Winship, founder of the *Grand Forks Herald*.[102]

Edwards's newspaper reflected his personality: staunchly Republican in political ideology and aggressive in promoting further development and investment in the growing community. He urged citizens to encourage their friends and family to relocate to the fertile Red River Valley and refused to allow regional (not local) newspapers to tout the severity of storms by proclaiming the area as "the most attractive winter residence north of the tropics."[103] Edwards was widely known to have ignored the more undesirable aspects of territorial life to promote Fargo to potential residents and, more importantly, investors.

Edwards's connections in Chicago helped boost his newspaper's reach; when President Ulysses S. Grant was contemplating running for a third term in 1880, the *Daily Argus* was a fervent encourager or, as the *Chicago Times* reported, "a lively Grant boomer."[104] One of Edwards's acquaintances from

his days in the Windy City was none other than *Chicago Tribune* editor Joseph Medill, and their relationship improved significantly after Medill decided to throw his weight behind Grant's bid for reelection.[105]

Edwards himself would end up dabbling in politics. In 1882, he decided to seek office in the territorial legislature, but his dust-up regarding the *Republican* and his old partner Hall came back to haunt him. Levi Allred opposed Edwards for the seat, so Hall's *Republican* started digging for dirt on Edwards. The newspaper ended up reprinting a sensational article from a Chicago newspaper concerning "fraudulent death losses of a Chicago life insurance company in which Edwards was an officer. He was depicted as robbing widows and orphans."[106] Edwards lost.

Spar with James J. Hill

Following his rousing loss for the territorial legislature, Edwards was hit hard again, this time by Mother Nature. On March 26, 1886, a fire destroyed the *Argus* building, which covered nearly a quarter of a block on Seventh Street. Unfortunately for Edwards, the loss was estimated at $40,000 but insurance only covered $8,800 of it.[107]

Edwards was sad that fire had consumed his library full of rare books (including a complete set of the *Congressional Globe & Record of 1832* as well as a copy of *The Official History of the War of the Rebellion*), but he was determined that his newspaper would not miss an issue. Edwards wrote:

> It has not been characteristic of the Argus to boast of what it intended to do, but rather to let each issue and each improvement speak for itself. The Argus is not disheartened, and has not lost its faith in Fargo, the people, Cass County, the Red River valley and Dakota. It might be impossible for the Argus to get through a daily test as severe as came unexpectedly upon it yesterday morning.

Many other local newspapers came to the aid of the *Argus*, thanks to Edwards's popularity among businessmen, by offering assistance and facilities despite rivalry tendencies. Many lauded him for his determination, such as the *Valley City Times*, which noted, "The indefatigable Major was not wholly disconcerted by the fire calamity...and announced...that the *Argus*, Phoenix-like, would arise from its ashes and continue on its mission of enlightening the world."[108]

Yet adulation and assistance only go so far. The Major could not recover from the extreme losses of the fire, and his plans to build a new brick building were waylaid by the debt he found himself in by December 1890. He took to the newspaper pages to complain of a lack of advertising support by the business community, and his major financier—railroad magnate James Hill—got nervous.

Tension between Hill and Edwards had already begun rising in the early 1880s because Edwards opposed railroad consolidations and sided with laborers when railroad workers went on strike, but they came to a head when Edwards couldn't meet his financial obligations. Hill foreclosed, replacing Edwards with noted Minneapolis editor George K. Shaw. Edwards's son John Edwards told the story differently: "Jim forced father to the wall and put another in charge" of the *Argus*.[109]

Twelve years after he started his first, Edwards found himself once again without a newspaper. Many thought that was the end of Edwards's publishing career, but not the Major. "It was generally assumed that 'Old Mage,' as many in the newspaper fraternity liked to refer to him, was at last down and out. He was down for the moment, but not out," his son recalled.

Two weeks after he lost the *Argus*, the Major asked Shaw to print a reply to some unsavory things that had been published. Shaw said no. Edwards got so mad that he "marched down to the telegraph office, wired for presses and type, and announced he would start another newspaper."[110] John recalled that "the majority of the state press plugged for 'Mage' and his new paper, and friends from all over the state sent in subscriptions to it in advance, accompanied by cash."

ANOTHER DAY, ANOTHER NEWSPAPER

Edwards enlisted a new partner, a Vermont native named Horatio C. Plumley, to manage the business end of the *Fargo Forum* while he himself took on the editorial responsibilities. (While the word "argus" means bright, all-seeing, Edwards selected a more diplomatic name for his new paper: "forum," meaning place of assembly for the people.) The Edwards/Plumley relationship was a productive partnership, the fruits of which exist today in the form of the *Forum of Fargo-Moorhead* newspaper.

Plumley originally worked for Edwards at the *Argus* (though he never gained the same recognition Edwards), so it made sense for him to follow Edwards when Hill ousted him. Their familiarity and knowledge of the

other person's working style allowed them to set up a new publication with relative ease.

Yet the people of Fargo weren't convinced a new publication was warranted. At the time, both the *Argus* and *Republican* were thriving. The public wondered whether Fargo could support another daily. Despite the speculation, the pair soldiered on, albeit with some hiccups along the way: the first issue of the *Fargo Forum* had to be printed over at the *Moorhead News* because the printing equipment had yet to arrive. That was November 17, 1891. The *Fargo Forum* wouldn't be printed in its namesake city until January 1892.

GUIDING PUBLIC DISCOURSE

Thanks to his positions at prominent daily newspapers, Edwards shaped public discourse in the young city. His ardent support of Fargo from his first days living here meant no issue escaped his attention. Fellow journalist Clement Lounsberry noted Edwards's influence as extensive: "Probably no paper has ever wielded or ever will wield a greater influence in the politics of the [Dakota] territory and state than that exercised by Major Edwards."[111]

While Edwards was noted for his kindness and soothing voice, his writing style was deemed "biting" and "belligerent," with touches of "humor and satire."[112] His "tell-it-like-it-is-style" of writing often took aim at his old newspaper, the *Argus*.[113]

> [Edwards] *was a good judge of human nature, and he employed it to advantage in building his papers. He believed like editors of today, that one way to build circulation was to say things about people which would interest them and their neighbors. But he did something more and, then he took off a man's scalp in a blistering paragraph, which was rather frequently; it is said that he always sent the victim a marked copy of the paper.*[114]

But he took on worthy issues like replacing mud streets with paved ones, organizing the fledgling towns of Fargo and Moorhead, creating health boards to stem infections and demanding finer homes for families. And he didn't just take on major concerns; Edwards also opined on the necessity of oral hygiene for children and productive sleeping habits.

His astute observations extended to the agriculture industry as well. He encouraged the use of irrigation, and he noted that sugar beets would be a great crop to raise in the Red River Valley twenty years before they actually

became a cash crop for the region. He even encouraged the use of voting machines rather than paper ballots more than sixty years before they would become commonplace in elections. Just six years after North Dakota became a state, Edwards encouraged the establishment of a state historical society: "Now is the time to start a state historical society, collect the early pamphlets, newspaper files and photographs of the first day of North Dakota, get the incidents from the men who first came here who are still alive and save this vast amount of information now easily available."[115]

Edwards was not above placing blame if the city didn't act quickly enough on the suggestions he presented through the newspaper. He is rumored to have created pen names "Sanitary" and "Gore" for letters to the editor he himself wrote regarding various sanitation and health issues in the city.

But Edwards wasn't just talk. He financially supported many civic endeavors that created a better Fargo. He helped organize the Fargo water company and invested in the paper mill, foundry, streetcars, electric lights and local gas plants.

One of Edwards's major concerns was fire. Back in 1871, he had seen in Chicago how devastating fire could be to a city, and in 1886, he experienced the destruction himself. He had reason to fear. In 1893, Fargo's business district was constructed of little more than derelict wooden buildings. Despite the Major's warnings, the city did nothing to promote construction with better materials.

The city paid dearly for that mistake.

In 1893, a fire broke out one day in June in a Front Street apartment and furiously engulfed several buildings, wiping out approximately 200 businesses and 140 homes in more than 160 acres at the heart of the city.[116] Because of the devastating events, the city established a fire department, passed a fire ordinance, created a city fire inspector and required stone or concrete sidewalks.

TIDE TURNS AFTER FIRE

The city of Fargo was devastated after the fire of 1893, but it was not beaten. Commerce resumed, more sound buildings were erected and the city continued to thrive. Edwards also saw his fortunes start to turn following the blaze.

The *Forum* building did not escape the flames, but it also didn't miss an issue. (Tour guides still recall that tenacity to groups of students who tour the

current five-story *Forum* building today.) The paper was late because the city had turned off the building's water supply so the press was unable to run; the edition after the fire had to be printed in the Western Newspaper Union in the *Argus* Building.[117]

One of the rival newspapers, the *Daily Republican*, lost its financial footing after the fire and was quickly bought up by Edwards, Plumley and the *Fargo Forum*. The purchase meant the *Forum* gained its subscriber list, advertising contracts and Associated Press franchise; the paper's name also changed to reflect the expansion: the *Fargo Forum and Daily Republican*. (The business community rejoiced at the merger because it meant one less newspaper to support with advertising dollars.)

Thanks to the fire, the newspaper also found a new home in the Odd Fellows Temple on the corner of Broadway and First Avenue north (just half a block west of the newspaper's current home). It would remain in that location until 1910.

The newspaper's continued success mirrored that of many businesses that persevered after the fire of 1893. Edwards praised Fargo's growth, noting that the resurgence occurred despite a financial panic and small harvest. "There are twice as many fine buildings in Fargo today as the most enthusiastic believer in the town predicted when the rebuilding commenced....There are modern conveniences of every sort and the city has demonstrated that, under any and all circumstances, it is the leading city of North Dakota."[118]

Edwards could not have known how soon after the fire of 1893 Fargo would be tested again; in 1897, the Red River overflowed its banks and flooded the city. Again, Fargo rebuilt.

MAJOR DAD

For all his ambitious civic and political contributions, Edwards appears to have been a devoted father to his seven children. His daughter, Marie, remembered Edwards as impulsive and intense, while their mother was more detached and introverted. The Major was a voracious reader and usually carried a book with him wherever he went, but he relied on his wife for more local news and information that she'd clip from other newspapers and magazines.

Father turned to her for real information. She, who had read much and remembered, could supply him with sources or proof of wanted materials

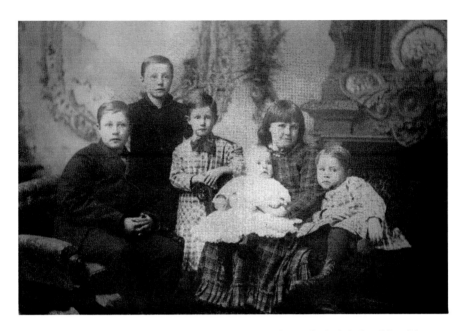

The children of Alanson and Elizabeth Edwards around 1885 included, *from left to right*, Harry, William, Alanson, George, Marie and John. Another son, Richford, was born in 1889. *From the* Forum of Fargo-Moorhead.

and with quotations. As she sat quietly, nursing her progeny, she read books and poems, clippings and the news topics of the day. To read them made them hers to enjoy and use. We were no bottle babies, but nurtured in living gentleness and security. The world was ours, but not to abuse. [119]

Reading was paramount in the Edwards house (a grand mansion on Seventh Street overlooking Island Park). Typically, the family spent an hour before dinner reading poetry or dancing before dining. (The Major's favorite poem was "Marching Through Georgia" by Henry Clay Work because he was exceedingly proud of having marched with Sherman to the sea, even though he was on horseback.) A favorite tradition in the Edwards house was learning a new word each morning. The children would learn how to spell it, what it meant and how to correctly pronounce it and then use it in a sentence.

Perhaps the Edwards children were taught to spell because their father was a notoriously terrible speller. "When an employee told him he wasn't much of an editor because he couldn't spell, Edwards told him, 'Why should I spell when I can afford to hire a scholar like you at $50 a month to do it for me?'"[120]

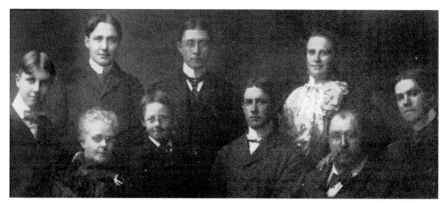

Above: The Edwards family in 1899 included (*back row*) William, Harry and Marie and (*front row*) George, Mrs. Elizabeth Edwards, Richford, Alanson, Alanson Edwards and John. *From the* Forum of Fargo-Moorhead.

Right: Marie Edwards Belknap became a widow in 1903 when her husband, Fred, died suddenly. Fred is buried in Riverside Cemetery in Fargo. *Author's collection.*

Reciting words and poems was common in the Edwards house, even if guests were present. "If we bored, our guests were too polite to show it. They really seemed to enjoy and were pleased to come again. A guest in the home was the first consideration, and hospitality the keynote," Marie recalled.[121]

That hospitality certainly extended to many at the holidays, for the big table that typically held about fourteen people burgeoned to twenty-two or twenty-four during special occasions, which called for numerous delicious dishes and a couple of turkeys for all the guests.

Marie also remembered attending the circus with her father, and "one of the Ringling Brothers took Father and me on a tour of inspection in and about the grounds of that circus." They even lunched with some of the circus performers. "I lived in a marvelous world of love and plenty."[122]

His son John Edwards remembered a happy childhood spent in a growing prairie city. He recalled that his father nicknamed Fargo the "Biggest Little City in the World," a slogan usurped by Reno, Nevada. "My bet remains on Fargo, and I can assure that, as a kid, Fargo really seemed to me to be the hub of the universe," he remembered.

As wonderful as Fargo was for the Edwards family, several members had to split up for a time when one of the boys, George, came down with rheumatic fever. Marie remembered her mother, grandmother and George moved to Florida for the winter, while the five older children went to Carlinville, Illinois, to live with relatives. (The youngest boy, Richford, was a year old and stayed in Fargo with a nanny.) They eventually returned to Fargo to finish school.

As a teen, Marie admitted to becoming sarcastic, but the Major wouldn't have it. He taught her slowly to say kind, not cruel things. "Always he had not allowed any one to make critical and unkind remarks. He would say, 'If you can find nothing nice about which to talk, just say, "He sings well."'"[123] The Major was "outstanding among the many outstanding ones in Fargo and throughout the territory," John recalled, noting the Major's sense of humor and his practical sensibilities. Marie said, "Father enjoyed jokes, even on himself."[124]

For his great sense of humor, the Major still demanded respect from his family, so the children called him "Papa" when they were younger and eventually "Father" when they grew up. But never "Dad." That was not a respectful way to address the Major, even for his children.

A FAMILY AFFAIR

During his most influential newspaper publishing years, Edwards often allowed his son John to hang around the newspaper office to serve as an errand boy and messenger. It was a thrilling experience for a young boy. "It was grand to see people come in to encourage Dad, leaving one, five, ten or more dollars, 'to apply to my subscription,'" John recalled. He marveled at one occasion when store owner O.J. deLendrecie made an unusual stop at the newspaper office to buy advertising space in the paper and wish the Major well in his endeavor. John recalled that because deLendrecie rarely left his emporium, the unexpected visit was quite appreciated by the Major.

John's time spent in the newspaper office meant he became acquainted with not only local prominent figures but national ones as well. He had the thrill of meeting Theodore Roosevelt when he came to North Dakota to regain his health. President Roosevelt even dined with the Edwards family at their home, no doubt enjoying a cigar with the Major while they talked politics. Other national figures who made stops at the *Forum* offices included President William McKinley, President William Taft,

William Jennings Bryan, Buffalo Bill Cody and "innumerable others of fame and repute."[125]

Alanson's son also recalled getting to know Norman Black Sr., the man who would eventually take over the *Forum*. Whenever Black stopped by the newspaper, John recalled, he always stopped by to chat with the young man. "Not once did he fail to step over to my desk, clasp my hand and say, 'Hello, Pete'—and pause, regardless of how busy he was for a moment of friendly chat," he said.[126]

CIVIC CONTRIBUTIONS

Edwards used his experience on the Chicago trade board to encourage the business community in Fargo to establish a chamber of commerce. The Fargo Commercial Club was created in November 1879 with twenty-eight businessmen signing on as charter members, including Edwards.[127]

> *But even in its early years, Fargo was attracting people of all walks of life and was offering a wide range of education and cultural opportunities even though it was hard on the frontier and not far from bands of Indians.... And throughout the history of the city of Fargo, the chamber has been active either in the forefront or behind the scenes to keep the city moving forward.*[128]

According to city council minutes, during Edwards's tenure as mayor, one of the fire department horses was named "Major" in his honor; the horse died in 1902. His daughter remembered that another fire horse was named "Edwards" after him, but she couldn't verify that particular story.

The Major had his own special seat in the new Fargo Opera House; he'd selected where he wanted to sit, and manager C.P. "Con" Walker (who had worked for Edwards previously in his Argus Printing Company) removed the two smaller seats and replaced them with one large enough to accommodate the Major.[129]

Thanks to his time spent as warden of the Illinois Penitentiary, Edwards served as a member of the first North Dakota prison board; he also served as superintendent of the Dakota territorial semi-decennial census in 1885.

LATER YEARS

At the close of the nineteenth century, Edwards had seen his fortunes wax and wane with his changing professional interests. He'd served as mayor of his beloved city from 1887 to 1888, so in 1888, he ran again for the territorial council, surprisingly earning the support of his former newspaper, the *Daily Argus*. The newspaper offered its best wishes to "a man who has done so much for Fargo and North Dakota" and "ought to receive unanimous support of everybody in his constituency."[130] The editorial continued, stating that "brains count in the legislature....Nobody believes the major deficient in that useful commodity."

While in the legislature, Edwards and his fellow legislators created the State Historical Society he had encouraged years before; the state even provided space for the new organization in its facilities.[131]

As the twentieth century dawned, Edwards turned his professional sights toward politics. He'd always been a fierce Republican supporter, and throughout the years, he had developed a close friendship with the powerful political boss Alexander McKenzie.

That friendship expanded to two other politicians, Judson Lamoure of Pembina County and Colonel Wilbur F. Steele of Steele; together, the quartet was referred to as "The Big Four" because they "were really big, burly, bustling men, larger in physical bulk than average, and what they lacked in brain was amply offset by brawn."[132]

When *Grand Forks Herald* editor George Winship ran for governor in 1900—against his buddy McKenzie's candidate, no less—Edwards's ridicule was fierce. (To his credit, Winship brushed off the criticism by labeling Edwards "a blabbering blatherskite and unprincipled hoodlum," but he never secured the nomination.)[133]

Major Alanson W. Edwards died in 1908 and is buried at Riverside Cemetery in Fargo. *Author's collection.*

Above: The Edwards family headstone is situated next to the Red River at Riverside Cemetery in Fargo. *Author's collection.*

Left: Alanson Edwards's daughter, Marie, provided crucial information and memories about her father for the *Forum*'s jubilee edition in 1950. *From the* Forum of Fargo-Moorhead.

In March 1902, Edwards's good friend President Theodore Roosevelt appointed the Major American general consul to Montreal, Canada. Edwards left the *Forum* in his son John's capable hands. However, failing health forced him to resign from the position by July 1, 1906, when he returned to Fargo. According to his daughter, Marie, the Major suffered a stroke while in Canada and lived the next two years as an invalid.

Edwards died on February 14, 1908, and "was sincerely mourned by an extremely wide circle of warm admirers. His work, however, lives after him."[134]

His wife, Elizabeth, passed away three years later. She'd been preparing to move to California, where four of her boys had moved, when she died suddenly. Marie recalled that "nothing was left for me in Fargo so I came out west to live. With my two small children, I started a new and entirely different life and for 37 years have basked in the sunshine of this glorious state."[135]

Even years after her father died, Marie remained in awe of him. "I revered my father," she said in her reminisces. "I thought he was the most wonderful man who ever lived. He was a companion and a friend. He turned no man away from the door. He would say, 'Better to help 20 who are undeserving than to miss one in need.'"[136]

NAMESAKE BUILDING

For all of Edwards's contributions to the city of Fargo and its early years, no building carries his name, at least not one etched in stone. Businessman and clothier Alex Stern opened his first store in 1881, eventually moving to a new location at 56 Broadway that was destroyed in the 1893 fire.

He started building a new store on the southwest corner of Broadway and NP Avenue; when the Major took note and asked Stern about the building's name, Stern replied, "The Edwards Building."[137]

Today, the Old Broadway restaurant occupies the Edwards Building.

THE LEGEND CONTINUES

Edwards newspaper legacy continues. The paper he founded in 1879 has now morphed into the largest daily newspaper in North Dakota and continues to be run by the descendants of Norman Black's family, the Marcils—the same Norman Black whom Alanson's son John recalls getting to know in

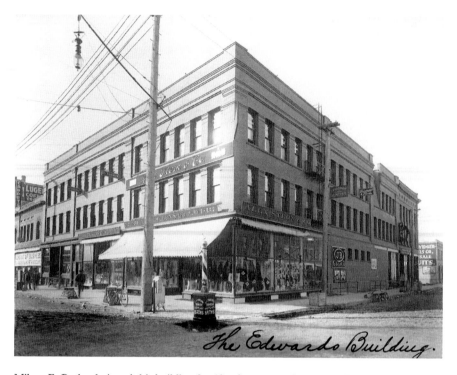

Milton E. Beebe designed this building for Alex Stern to replace an earlier Edwards Building that burned on January 9, 1903. *Institute for Regional Studies, NDSU, Fargo (2047.4).*

the office. Edwards was inducted into the North Dakota Journalism Hall of Fame in 1939.

To this day, Alanson William Edwards remains a powerful, if somewhat uncredited, force in the history of the city he loved so much. "Fargo was his pride and he watched it grow into a city and felt he had a large part in its development," Marie remembered.[138] A November 14, 1978 *Forum* article wrote:

> *He was a big man. The extent of his influence in Dakota Territory and the fledgling state of North Dakota matched his physical dimensions. He was a dominant figure in the life of Fargo from his establishment of* The Republican *in 1878 until his death in 1908 and was one of the recognized giants in the political, social and economic life of the region he fondly called "The New Northwest," that area of Minnesota, North and South Dakota that Fargo-Moorhead claims as its trade territory.[139]*

FAMILY LEGACY

For as much information as you can find about Alanson William Edwards and his many endeavors in Fargo, little is known about his children and his descendants. Chris Edwards is the great-grandson of Alanson William, but he said he's had a hard time finding any information about his relatives.

Chris's father was Jack Robertson, the son of Alanson Charles, Alanson William's son. Chris's father was a marine who rarely talked about his childhood or his illustrious grandfather. Chris lives in Florida now and is curious about the legacy of Alanson William Edwards, though he's never visited the city his great-grandfather helped build.

Even though Chris has few details about his extended Edwards family members, he is carrying the name Alanson into the future. His son is named Alanson Charles Edwards III. Elizabeth is also a popular name for the wives in his family—Alanson Williams married Elizabeth Robertson, and Chris's father, Jack, married Elizabeth McDermott. Chris's wife's name? Elizabeth Huntington. Alanson's son George also married an Elizabeth—Elizabeth Darrow O'Neill—in September 1919.

Chapter 8

MELVINA MASSEY

Fargo's Main Madam of Ill Repute

Nearly 125 years ago, a woman who would eventually etch her name in the annals of Fargo's early history stepped off the train onto the platform of the Northern Pacific Railroad depot.

As a fifty-three-year-old African American woman, Melvina Massey was not an obvious candidate for success. A growing village built on the banks of the Red River, Fargo lacked racial diversity (1885 census records indicate only two African Americans lived in Fargo) but teemed with opportunity.

In 1871, Massey was one of many ambitious transplants who arrived on Front Street (later renamed Main Avenue) via the railroad, an entity that made Massey's future business venture possible in the first place. A busy railroad and agricultural sector required men to build the roads and work the fields. Droves of single men meant the world's oldest profession had found yet another market.

Back then, Fargo (which was actually called Centralia until 1873) only had six hundred inhabitants. Within a year of Massey arriving from her home state of Virginia, the city boasted more than eight thousand people, and "the tents and shanties of earlier days had been replaced by mainly wood-frame buildings."[140]

Massey built one of those wood-frame buildings at 118 Third Street North in 1891.[141] She wasn't alone, though. Elmo Anderson, Pearl Adams, Stella Dorsey and musician Coleman Butler are listed as boarders; could this have been Melvina's first foray into the brothel business that made her famous?

A PALACE FOR PROSTITUTION

That same year, Massey purchased property at 201 Third Street North and immediately made plans to establish a brothel called the Crystal Palace. Her "palace" resided in a less-than-royal section of early Fargo referred to as the Hollow, the poor section of town along the river where immigrants and laborers lived. The footings of the house were buried below the city hall parking lot next to the Red River.[142]

A savvy businesswoman, Massey immediately started making connections in the city. She "let it be known she was interested in investing money in property here. She dined at the Headquarters Hotel in grand style by the leading men and women of the day."[143]

Once the Palace was ready, Massey distributed invitations to the grand opening to Fargo businessmen—engraved ones, no less.

PAYING HER DUES

Brothels and prostitution were illegal at the time, so law enforcement officials enforced regular fines on "houses of ill repute." These "necessary evils" actually meant more municipal income and expanded commerce.

The boardinghouse at 201 Third Street North was a brothel called the Crystal Palace, operated by madam Melvina Massey. *Institute for Regional Studies, NDSU, Fargo (2007.0106-02).*

Each month, owners of brothels were arrested and brought to court to pay $56.50, more than $1,400 by today's standard; those fines helped pay for additional police officers who patrolled the unsavory area. Massey paid up regularly each month, indicating her success was great enough to finance the cost of doing business.

City officials suddenly became suspicious of the activity in the Hollow because the mayor contacted the *Fargo Forum* saying "the denizens of the hollow are not all paying fines—or not all are being paid into the treasury."[144] No records indicate Massey ever missed a payment, but her profession caught up with her eventually.

In 1901, she was convicted on charges related to alcohol (prohibition was big in Fargo at the time) and sent to prison in Bismarck.[145] Massey surrendered willingly and was accompanied to the penitentiary by Cass County sheriff Treadwell Twitchell. She had the "distinction of being the only female prisoner in the penitentiary."[146] The sixty-three-year-old Massey wisely chose to mind her manners. Because of good behavior, she was released after serving less than a year.[147]

SALACIOUS SUCCESS

Angela Smith is a North Dakota State University (NDSU) history professor who has been researching Massey since 2012. Smith said Melvina's time in prison was merely a blip on the radar for the successful businesswoman. According to a newspaper article, "She had friends waiting for her at the train station" when she was released, Smith explained.

After returning to Fargo and her Crystal Palace business, Massey's life continued in the same ebb and flow of serving a need in a growing community while paying her monthly fines. Her business continued to do well, but her health declined. In May 1911, Massey died in a local hospital, with her obit recognizing her as a "well known character in Fargo."[148]

Massey's extensive probate record indicated just how successful she had been. "She owned a big brothel with lots of things; she wore furs," Smith explained. "[The Crystal Palace] was an upscale brothel for Fargo. Among her belongings were diamond earrings (valued at $75 in 1911, which would be more than $1,800 today), fancy pillows and china, a gilded parlor set (worth $15 in 1911 or nearly $400 now) as well as a fur coat and accessories."

Massey had style, and so did the Crystal Palace.

MISSING PIECES

Massey's name would most likely be lost to history were it not for Smith and her research efforts. Smith led a history class that was researching taboo topics in the Fargo-Moorhead area's history (think crime, KKK and prostitution), and Massey emerged as a prominent figure thanks to court records. "She's one of my heroes," Smith said, grinning.

Smith and her class created a documentary about the brothel owner, and Smith continues to dig for clues about the famous Fargoan. Much of Massey's life remains a mystery, but Smith is doing all that she can to uncover more details about the woman's life.

Smith has researched the Twin Cities area to ascertain whether Massey may have stopped there on her journey from Virginia to Fargo; she's even uncovered an African American madam there who may or may not have been a mentor to Fargo's famous madam.

Massey's family is also a source of mystery. She gave birth to a son named Henry Gray in 1859, and Smith wonders if Massey may have been a slave at that time. Census records provide few details about her son or her husband, Henry Rae. Even more confounding are myriad records that list individuals with varying names—Melvina Gray, Henry Charles, Melvina Rae.

What Smith finds most fascinating about Massey is the fact that she found success at a time when the odds were working against her. "She isn't a victim; she had lawyers and money and went to court unafraid," Smith explained.

Where Massey's money came from is another source of speculation. Smith discovered a court case involving a Melvina Massey (whether it is the same madam from Fargo has yet to be proven) and a lawsuit against a carriage driver who reneged on a marriage proposal. Smith explained that the case was handled in Washington, D.C., but the Massey from Fargo was from Loudoun County, Virginia. Loudoun County borders Washington, D.C. The Melvina Massey involved in the case won, receiving a $5,000 settlement.

Yet Smith remains skeptical with no evidence to corroborate historical facts. Was the Melvina Massey in the D.C. court case the same woman who found success in Fargo? Was the money from the lawsuit what Massey used to establish her business? Did she leave Virginia so as not to bring shame on her family?

We may never know, but Smith hopes to continue unraveling the mystery of Melvina Massey. "This woman came to this place and carved out a space for herself," Smith explained. "Don't we want her to be known for that regardless of what she did as a profession?"

FAMILY TIES

Descendants of Melvina Massey are just as fascinated with her story as Smith and many others. They have traced their family back to Melvina's father and her son and operate a Facebook page and website dedicated to chronicling their history.

Melvina's great-grandson Brandon visited Fargo to research his famous relative; he documented his findings in a video series available on YouTube.

DID YOU KNOW?

Early references to prostitution often included the word "inmate." The term did not always refer to someone incarcerated in prison but rather "confined."[149] Think patients in long-term care facilities, reform schools or county homes.

Fargo's red-light district was also known as the Hollow. The term "red-light district" universally refers to areas of a city containing brothels, made famous by the district in the Netherlands. While not historically established, rumors abound that the term originated from the railroad.[150] Men working on the railroad left red lanterns on the doorstep of the brothels they frequented at night so their colleagues could locate them in an emergency.

Sanborn Fire Insurance maps from Fargo's early years include many female boardinghouses, which is one of the ways we know the Hollow existed. However, the maps for Bismarck, Jamestown, Valley City and other area cities contain no labeled female boardinghouses. Those towns had brothels, but the mapmaker did not label them as such.

A version of this article originally appeared on danielleteigen.areavoices.com. The post earned second place in the Personal Blogs category of the 2016 NFPW Professional Communications Contest.

Chapter 9

PETER ELLIOTT

Famous Fargoan Named Building for Elusive Daughter

In downtown Fargo, the Loretta Building is one of the most popular establishments thriving with local businesses, swanky retail shops and modern offices. A stately structure nestled nicely in the center of historic Broadway, the building is a tribute to the daughter of one of Fargo's mayors, Peter Elliott.

Unsurprisingly, much is known about Elliott himself. The son of Irish immigrants, Elliott came to Fargo in 1873 by way of a yoke of oxen, established himself as a prominent businessman and eventually became mayor of Fargo.

Yet very little is known about Loretta Elliott. She was the second-to-youngest daughter, despite frequent reports that Loretta was the youngest. The reason Loretta's name graces the building stems from her father's success as an early Fargo businessman.

As a seventeen-year-old, Elliott left the home he shared with his parents in St. Paul and journeyed north.[151] He worked his first summer in Fargo as a cabin boy on the steamboats that traveled the Red River between Winnipeg and Breckenridge.[152] He returned for the winter to St. Paul, where he worked as a government surveyor, but came back to Fargo in the spring of 1874. He worked his way up to pilot, demonstrating his "keen judgment, steady nerves and an accurate knowledge of every crook and turn in the twisty Red River."[153]

Loretta's parents have the river to thank for bringing them together. Elliott met his wife, Mary Meade, while in Winnipeg for his job on the river.[154] The two married in 1881 and moved to Fargo shortly after the wedding.

SETTING UP SHOP

The Loretta Building graces Broadway, the historic thoroughfare that runs north and south through the heart of Fargo. But Elliott's business success has roots on Main Avenue, another historic street that intersects Broadway. Once back in Fargo, Elliott opened a restaurant on Front Street (now Main Avenue) and Fifth Street in the basement of a building owned by Martin Hector.[155]

He quickly found success, and two years later, he inched northward by leasing a large three-story hotel on NP Avenue (short for Northern Pacific, the transformative railroad that prompted Fargo's growth). Elliott's hotel, which was just west of the prominent Citizens National Bank, soon "became famous as the headquarters for thousands who visited the city."[156]

This popular house offers peculiar attractions to the most discriminating class of the traveling public, merchants and commercial travelers, who find here the comforts and accommodations desired. The Elliott House

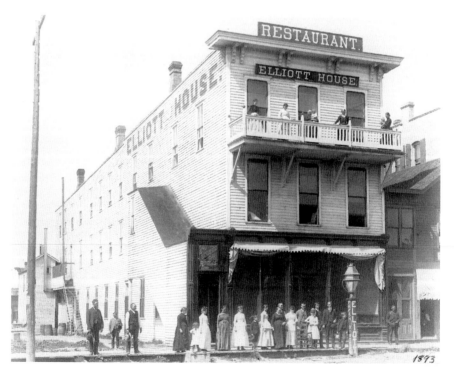

Peter Elliott's first building in downtown Fargo was a three-story wood-frame hotel destroyed in the fire of 1893. *Institute for Regional Studies, NDSU, Fargo (rs007289).*

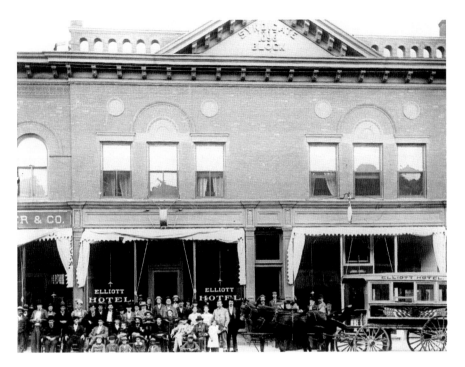

Peter Elliott built this two-story brick building after the fire of 1893. The Elliott Hotel was located at 68 Broadway in the Syndicate Block. *Institute for Regional Studies, NDSU, Fargo (Mss1970.25.34).*

has sixty well lighted and airy rooms, and with a cuisine that is, beyond peradventure, the very best, the tables being supplied with each and every delicacy the season affords.[157]

Moving north meant Elliott's first namesake hotel was, unfortunately, a victim in the great Fargo fire of 1893.[158] The hotel, which was at the height of its popularity, burned to the ground. The Elliotts had been planning to leave town, but they stood on the train platform, watching the smoke rising into the sky, and knew they couldn't go.[159] "The day of the fire they were on the N.P. platform waiting for the train, packed and ready to go on a trip. They smelled smoke and as it was a hot, windy day realized it would be a big fire....The Elliotts, rather than depart as scheduled, called St. Paul and ordered the largest tent available to be sent to Fargo on the night train."[160]

The next day, Elliott erected two enormous tents—one served as the kitchen and the other a dining room. In those two tents, Elliott and his staff served a meal to the people of a stricken city. Those tents continued to serve

as a temporary restaurant throughout the rest of the summer, and Elliott joined forces with many other prominent businessmen and community leaders and purchased a large section of the demolished business district.

The block became known as the Syndicate Block of Broadway, and Elliott quickly established a new hotel in that prime downtown real estate. The steam-heated structure had "comfortable and well furnished sleeping rooms," making it "one of the best and most agreeable hotels…with pleasant surroundings" where "appetizing and well-cooked meals were served."[161]

The lobby of the Elliott Hotel was in the middle of the Syndicate Block, with rooms above. Most of the upstairs was used as a hotel. The lower floor housed stores and the office and dining room of the Elliott Hotel. It was a popular hotel, and the dining room provided a meal with three kinds of roast meat, fish and all the trimmings, plus several kinds of pie for 25 cents. The hotel maids served as waitresses at meal times. Apparently, Mrs. Elliott knocked on the doors of the guests' rooms on Sunday mornings encouraging them to go to church. Mrs. Elliott died April 2, 1904. The rooms did not have baths, and some had no windows but rather a skylight over an open court that the rooms faced. A small wooden addition at the rear provided rooms for maids.[162]

Elliott was described as a quiet and unassuming citizen of the community with a romantic career that surpassed many others. He was one of the "oldest hotel men in the Northwest and is widely and favorably known among traveling people."[163]

More Than Just a Businessman

Loretta Elliott's father had established himself as a quintessential businessman by the turn of the twentieth century. If you knew Elliott, you knew Fargo. Known as an ambitions businessman and popular caterer in the community, as well as a fair and amiable property owner, Elliott was a respected man in a new and thriving community and a familiar figure in the city.

Thanks to his success, Elliott was able to give back to his community. He was a member of the state board of regents for six years, a post he'd been appointed to by John Burke during his time as governor (1907–13). Elliott also served as a director of the First National Bank of Fargo.

More importantly, Loretta's father was quietly charitable, often helping people in need by offering them a room in his hotel. "The oldtime residents of the city who knew him will say that no one who made an appeal for aid was ever turned away without help."[164]

In 1907, Fargo mayor John Johnson died suddenly during his term. Elliott was serving on the city council and was elected unanimously, indicating the "high estimation in which he [was] held by members of city council."[165] Elliott served from 1907 to 1910.

In his sixties, Elliott sold his hotel and at some point moved to California. That's where he died in 1928 in a hospital in Glendale; he'd

Peter Elliott was an early hotel owner in Fargo's early years who served as mayor from 1907 to 1910. *City of Fargo.*

been experiencing heart issues for several weeks. His wife had already been gone for decades; Loretta's mother, Mary, died on April 2, 1904.[166]

THE LORETTA BUILDING

In 1909, Elliott began his plans for the Loretta Block, which covered the southern two-thirds of the 200 block of Broadway. The construction happened in stages, with the Loretta Building being finished in 1912.[167] By 1923, Elliott decided to sell his hotel to A.L. Moody, who leased the hotel and the retail store space for several years. The hotel ended up back in the estate of Peter Elliott, but in 1947, Scheels Hardware, Bergstrom and Crowe Furniture Company and George Black's Store Without a Name took over the property.[168]

The building's tenants for the next sixty-three years included a furniture company, cattle company, hardware store, electronics retailer, paint store, jeweler and others.[169] Then, Kilbourne Group—headed by entrepreneur and downtown advocate Doug Burgum—acquired the building in 2010 and breathed new life into the historic, century-old landmark.

When Burgum purchased the Loretta in August of 2010, he found a Grand Dame who had weathered decades of neglect. Only about 9,000 square feet of the sprawling structure was used; the other 70 percent of the building was uninhabitable. "It was a lady in distress," Burgum says. "The buildings are like kids who can't defend themselves on the playground."[170]

But now that the building has been restored to its former glory, what about its namesake? What ever became of Loretta Elliott? Information is scant, records few. In the 1922 City of Fargo directory, she is listed as a student living at 702 Broadway, which appeared to be the Elliott family home; she was still listed as living at that address in the 1930 directory, though she was not deemed a student in that listing.

The Elliott family was big, with five daughters and three sons. Loretta's aunt Miss Ellen Meade had lived with the family in Fargo since Mary married Peter back in 1881. (Strangely enough, she was listed as "servant" in the 1900 U.S. Census record.)

Loretta's sister Margaret married J. Frank McKone[171] of Fargo, a cigar and beverage business owner, in 1909. The McKone Building at 206 Broadway, which was built in 1905, stands directly to the south of the Loretta Building. To the north of those buildings is the Powers Hotel, named for another "original paterfamilias of downtown Fargo"[172] connected with the Elliotts. Loretta's youngest sister, and the final Elliott child, Elizabeth, married F. Urban Powers[173] in 1929. Their father had just died the year before, so Elizabeth's brother-in-law Frank McKone walked her down the aisle.[174] Loretta served as maid of honor for her younger sister.

That's where information about Loretta dries up. According to the 1940 U.S. Census, Loretta was living in Los Angeles, California, and had married Sam Balacco. Other people living in her house at the time were Franklin Fax, sixty-nine, and Marjoria Fax, sixty, as well as Francis Dearmond, nineteen, and A. Brooks, thirty-five, and Harriett Brooks, thirty-two. The census records don't indicate relationships, but the latter two may have been related; Margaret McKone's obituary indicates that her only daughter, Mary Brooks, preceded her in death.

Mary Jo Powers Reimer, Loretta's niece, grew up in Fargo but now lives in Arlington, Virginia. Her mother was Elizabeth, but Reimer admits she doesn't know much about Peter Elliott. She actually lived in the Elliott family home at 702 Broadway, which was placed in the National Register of Historic Places in 1987 but was later removed; the area where the home was is now a parking lot.

While the Loretta Building continues to epitomize the downtown renaissance in Fargo, the woman for whom the building is named remains a mystery. She's often incorrectly listed as the youngest daughter of the Elliott family, though she was the second youngest.

So why did Elliott name the building for her and not Elizabeth, his youngest daughter and child? Furthermore, why did he name its neighbor after his oldest daughter rather than himself or a son? We may never know, but we do know Elliott left behind two important relics by which to remember him...or at least his daughters.

O.J. DELENDRECIE

Merchant's Great Dream Still Lives On in Fargo

M any buildings in downtown Fargo have undergone radical transformations, whether externally with new or refurbished façades or internally as renovated structures with new purposes and plans. One of the few historic gems in the heart of Fargo that remains largely untouched by time is deLendrecie's. The once giant of the retail world stamped its name in the sidewalk leading up the store, and it's still seen on the side of the building as well as the main entrance welcome mat.

Back in 1894, the stately, Richardsonian Classical building emerged in the Fargo business scene as a mercantile hub in a new city; today, deLendrecie's remains a center for commercial and retail activity in downtown Fargo. The building is the brainchild of Onesine Joassin "O.J." deLandrecie, a Canadian immigrant who originally intended to become a teacher. But he never did.

COMING TO AMERICA

DeLandrecie was born on December 11, 1845, in Quebec and received a private education thanks to the money from his old family who had emigrated from their ancestral home at Landrecies in northern France.[175] He went to college en route to a teaching career, but he ended up selling to lumber camps before moving to Paris, France, to open a lace store at the age of nineteen.

Though deLendrecie's is also known as Block 6, it still bears the name of the man who built it in 1894. *Author's collection.*

At some point, deLandrecie immigrated to America and changed his name to deLendrecie.[176] He spent time in Chicago until the great fire of 1871 sent him searching for other opportunities. Those were found in Missouri—Yazoo, to be exact. That's where he and his younger brother opened a dry goods store, but they eventually sold it after deciding in 1879 O.J. and his wife should move to Fargo. He married Helen Josephine Basefe on September 7, 1879, in Racine, Wisconsin, and a month later, he was in Fargo searching for a potential site for a new store. "When the founder first decided to establish his own business, it took him just a few hours to decide on Fargo as the location for his proposed store. He was told there were four centers in the country where he could best locate—Kansas City, Chicago, the Twin Cities and 'a new town, then getting much publicity, called Fargo.'"[177]

Selecting a site in Fargo didn't require too much of deLendrecie's time. He arrived in the morning, selected a site by noon and by the time the sun had set, he'd had plans drawn up for his new business venture. DeLendrecie spent $2,000 for a lot at 618 Front (now Main) Street, where he built a small store called Chicago Dry Goods. When land prices increased so greatly, deLendrecie was offered $18,000[178] for his lot, though he declined. Land prices eventually returned to previous values.

DeLendrecie's quick decision about where to build his store likely seemed a bit rash. Many in the business community were surprised he selected a site "so far west" on Front Street, yet deLendrecie had "the faith in the Red River Valley to realize that the city would soon expand far to the west and south—as well as to the north—which it did."[179] A less idyllic explanation is the fact that the land was located across from the Northern Pacific Railroad depot. Years later, he changed the named to the O.J. deLendrecie Company.

DeLendrecie enjoyed early success with his store, offering a basic selection of fabric, clothing, sundries, men's clothing and buffalo hats trimmed in beaver.[180] The great Fargo fire of 1893 ended up being a blessing in disguise for the merchant. Thanks to an abundance of available (and now empty) lots, deLendrecie tripled his real estate investment and quickly built another two-story brick building—"handsome and imposing"[181]—next to his current store, a store he called the "Mammoth Department Store," though "it was not as mammoth as department stores go nowadays, but it was considerably larger than the little Chicago shop."[182]

[The building] *is the natural result of Fargo's growth and is another evidence of the metropolitan character of the business houses erected since the fire. A glance at the accompanying cut will convince anyone that Mr.*

Left: Canadian Onesine Joassin "O.J." deLendrecie founded his dry goods business shortly after arriving in Fargo in 1879. *From the* Forum of Fargo-Moorhead.

Below: This view of Waldorf Square in 1909 shows deLendrecie's department store across the street from Waldorf Hotel. *Institute for Regional Studies, NDSU, Fargo (2006.17.27).*

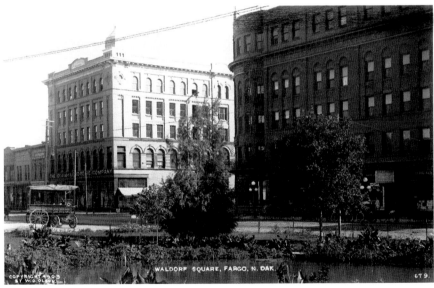

deLendrecie has carried out in this building the idea which prompts him to do all things well, namely; to have nothing that is not first-class.[183]

DeLendrecie's quickly became the largest department store between the Twin Cities and Spokane thanks to its "exquisite merchandise of the highest quality."[184] When the expanded store open, the inventory included china and

glassware, beautiful home furnishings and sumptuous fabrics handpicked by deLendrecie's brother and business partner, Eugene.[185] Hailed as an elegant store teeming with customers, deLendrecie's was "the finest in northern Dakota and the pride of Fargo."[186] "The main sales room will be finished in maple and quartered oak; there will be seventy feet of plate glass show cases and handsome racks for the advantageous display of goods, besides the hundreds of feet of counters and shelving."[187]

In addition to a successful store, deLendrecie also established an important trade network extending throughout Minnesota, Montana and the Dakotas.[188]

GIVING BACK TO THE COMMUNITY

Not only did deLendrecie enjoy success in the business world, but he and his wife were active community members as well. He served as vice chairman of the Democratic National Committee in 1893 during President Grover Cleveland's presidency, yet deLendrecie always put the city and state's needs above any partisan politics.[189] He became the first business in the community to purchase a full-page advertisement in Major Alanson Edwards's new newspaper, the *Fargo Forum*, offering a $500 check for the marketing.[190] DeLendrecie also assisted in the founding of the Fargo National Bank, serving as vice president; he was also a Mason and a member of the Commercial Club (which became the Chamber of Commerce) and other social organizations.[191]

As his business grew, so did his store; by 1904, his retail space had grown by two stories. To celebrate his wealth, deLendrecie bought land on Detroit Lakes and created a "showcase summer home."[192] He continued to expand his real estate investments by buying huge sections of western North Dakota land, most famously President Theodore Roosevelt's Maltese Crossing for a cool $15,000.[193]

As the wife of a prominent businessman, Helen deLendrecie found herself leading the Civic Improvement League as well as chief fundraiser for the Unitarian Church in Fargo. "Her chief cause was promoting the emerging alternative medical practice of osteopathy, a therapy that stressed 'the body's ability to heal itself.' Helen claimed she had suffered from breast cancer and was cured through this practice."[194]

Osteopathy is known today as a branch of alternative medicine that involves the manipulation of bones, joints and muscles to treat medical

issues. Helen lobbied hard for osteopathy to be recognized legally as a medical practice, even though the majority of the medical community opposed such a designation; the legislature came through, and Helen eventually went on to create an entire school founded on the practice—the Northwestern College of Osteopathy in Fargo.[195] She was president of the college until A.T. Still University absorbed it in 1905.

Next, Helen took on the suffrage cause; as the twentieth century dawned, Helen was elected secretary of the Equal Suffrage Association of North Dakota, creating a headquarters office within her husband's store.[196] Unfortunately, her efforts were unsuccessful during the 1911 session when a bill allowing women the right to vote failed.

By 1914, deLendrecie had decided it was time to retire to greener pastures. Not literally of course, but he did hand over management of his store to his brother Eugene J. deLendrecie and move to Los Angeles. His last visit to Fargo was in 1918. He died in 1924, and Helen followed two years later.

The Future for deLendrecie's

Eugene continued to manage the store until 1940, when two nephews, O.J. Campbell and Duncan Campbell, stepped in. In 1955, the Campbell brothers sold the store to Mercantile Stores Company out of New York. Three years later, the store began contributing to profit sharing accounts for the store's forty-eight employees. In 1961, a coffee shop was added in the basement of the store, and one year later, a parking lot big enough for 128 cars was built by TF Powers Construction Company.[197] The space had become available after the Fargo Auditorium and Armory was razed in 1962.

In 1972, deLendrecie's joined Sears and Roebuck as the first occupants of the West Acres Mall. The move to the mall expanded retail space from forty-five thousand square feet to ninety-one thousand, but deLendrecie's eventually left in 1998, at which time current tenant Herberger's moved in.

Once deLendrecie's moved to the mall, the other stores and offices that had rented space began moving out, effectively abandoning what was once the retail hub of downtown Fargo. Fortunately, the abandoned building found new ownership just a few years later in 1975 as an apartment and commercial complex that was remodeled to resemble the first department stores of the nineteenth century.[198] The new owners honored Fargo's early history by naming each floor with a historical reference:

Above: Today, the deLendrecie's building is home to retail shops, a restaurant and several apartments. *Author's collection.*

Left: A stamped piece of concrete on the sidewalk in front of deLendrecie's indicates the building's history. *Author's collection.*

Lower level: Centralia
Main level: Front Street
Second level: Fargo on the Prairie
Third level: Fargo in the Timber
Community room: Tent Town (which is what Fargo was at first)[199]

In fact, the new building's official name became "Block Six of the Original Townsite," in homage to Fargo's early founding across from the railroad depot. In 1979, deLendrecie's earned a spot in the National Register of Historic Places because it exemplified "the opulence and optimism with which the Fargo business community entered the twentieth century," as well as the business boom after the great Fargo fire.[200]

Part V
Prairie Doctors

Chapter 11

MATILDA ROBERTS

*Pioneer "Mother" First Pharmacist
and Successful Businesswoman*

Broadway is the main thoroughfare through historic downtown Fargo, but nearby is another street with an important history. Roberts Street is named for a famous Fargo lawyer named Samuel Roberts, whose practice once anchored the street.

But his practice would never have been placed there had it not been for his cousin's wife, Matilda, a pioneering woman who watched Fargo emerge from virgin prairie to become a successful mini-metropolis. Hers is a story of resilience and fortitude, of stamina and savvy. Her story "is the folklore of Fargo."[201]

LEAVING HOME FOR THE UNKNOWN

Back when Fargo was just untouched land with a planned railroad stop, Charles Roberts and a handful of other pioneer men tried to determine where that elusive stop might be; railroad officials were working hard to evade any chance that these settlers would lay claim to ideal land before they secured the rights. The pioneers thought the stop might be north of the present-day city, where Oakport is. After that trick was ciphered, they picked up their tents and moved south where the real stop was.

At the time, everyone lived in tents. Surveyors and engineers lived in tents in Fargo on the Prairie, while the ruffians and drunks lived along

Charles Roberts was one of the first settlers in Fargo in 1870; a subdivision near downtown is named after him. *From the* Forum of Fargo-Moorhead.

the river in Fargo in the Timber. Matilda was used to pioneering by the time she found herself on the dusty prairie of Fargo with its "brown stretches of land… that wandered aimlessly away to meet the hard blue sky."[202]

As an eight-year-old girl, she and her parents, Dr. and Mrs. John Morin, left Canada and staked land forty-five miles from St. Paul.[203] She married Charles Roberts in 1869, sharing his restless spirit. That's how she ended up on the plains of North Dakota—Indian country as she knew it at the time; she'd had only a day to pack up her young family when Charles rushed into their Minneapolis home and asked if she would come with him. And when she arrived in August 1871, Matilda was one of four women in Fargo.[204]

The young Matilda was a welcome member of fledgling Fargo. The other pioneer men they joined were especially excited about her cooking after she served them a delicious meal of "fluffy biscuits, baked in a wash dish, baked potatoes, beef and other hardy foods that pioneers liked best."[205] She cooked the entire feast over a campfire, and they ate it all outside on the prairie.

Thanks to her husband's pioneering ways, Matilda claimed the honor of giving birth to the first white child in Fargo, a boy named Lee, in 1871 in a one-room barn. She even delivered him by herself because Charles was out looking for help when the baby arrived.[206] He did bring back help, Mrs. Sarah Egbert, the wife of Fargo's eventual first mayor, George Egbert. The elderly Mrs. Egbert helped Matilda recover from the delivery and looked after her and the baby until Matilda was back on her feet.[207]

That first winter, they hibernated in a tiny one-room barn with their horses, "like rabbits in a burrow," Matilda said. "Sometimes I can hardly believe that we lived through those hard days."[208] Matilda and Charlie considered themselves lucky to have a one-room barn. It was warm and habitable, but Charlie was out of town on business so much that Matilda grew weary of her living arrangements.

Giving birth to a baby in a barn is one thing. Living in a barn with an infant and his older toddler brother Willie was another thing. Plus, the constant threat of Indian attacks loomed large over Matilda's modest home. So Charles set about building a new home for the young family in 1872, a two-room log house "on a knoll on what is now the even side of Eighth Street South, at the ravine."[209] It was the first home in Fargo. Matilda's third son, Charles Milton Roberts—known as Tad—was born on November 23, 1873; Mrs. Egbert again helped deliver the child.

Matilda Roberts came to Fargo in 1871 with her toddler son and husband, Charles. She gave birth to the first white child in town. *From the Forum of Fargo-Moorhead.*

Charles wanted to make even more money, and the Black Hills gold rush of 1876 beckoned. So he left to find a gold mine to buy. The situation worsened when the news that General George Custer's Seventh Cavalry had been annihilated at the Battle of Little Big Horn reached Fargo. Matilda paid her respects to the widows of all the officers when they came on a train to Fargo and walked in "a tragic procession" into the Headquarters Hotel.

> *Mrs. Custer came first, waxen, remote, walking in a trance; her eyes looking through and past the crowd. Mrs. Calhoun came, with her fourfold grief for she had lost a husband and three Custer brothers. Young Mrs. Yates came with her two wondering children. One after another, the 26 widows moved on, through the crowd, into the hotel, up the stairs. Widows, 26 widows.*[210]

Matilda never forgot that chilling experience. And Fargo was on edge. Rumors of Indian attacks swirled throughout the tent camps, and Matilda grew leery. Charles had previously had some close calls with Indians while he was taking supplies to Custer's troops, and he loved to regale his young sons with those tales. Matilda didn't. "They made her feel cold as stone. As a matter of fact, the Indians never molested the lonely cabin on the prairie.

They did ride up; they did beg for food; they did pass their murderous hands over the fairness of her babies."[211]

The Indians never threatened Matilda, yet she feared them. Charles had taken a break from his lumber business to go prospecting, and she didn't hear from him for nearly a year. She was scared Indians had scalped him.

But Matilda soldiered on. She saw that one of their storefronts had the makings of a drugstore—ten gallons of castor oil and many bottles of patent medicines. So Matilda became Fargo's first pharmacist, relying on the knowledge she'd learned back in Minnesota, where she spent hours in her father's office reading a "treasured copy of Dr. Gunn's Household Physician."[212] "So Matilda helped where she was needed. We see her, a wiry, chestnut headed woman, hurrying into the homes of the frontier town, with her aconite and belladonna, her purges and emetics....She did immeasurable good."[213]

In her later years, Matilda recognized the wonderful doctors who set up their practices in Fargo in the 1880s, but before they arrived, Fargo had no doctor. The city only had Matilda. During her time as one of Fargo's prairie doctors, Matilda assisted in the births of at least twenty-three babies.[214]

BECOMING A BUSINESSWOMAN

Soon after, Matilda ventured into dressmaking, opening a shop that proved so successful she hired a "cutter and fitter from New York and two seamstresses."[215] She began by sewing clothes for her own family and then branched out to more people, like her husband's cousin, Samuel, who wore her finely tailored clothes for ten years. Thanks to Matilda's business, the small city of three thousand offered women modern clothes seen in Paris and New York City. The wives of pioneer settlers wanted finery, and Matilda met their demand. "The shop was successful from the moment it started. There was no ready-to-wear industry in those days. The wives of the settlers had endured poverty and privation for several years. As soon as their husbands made a little money their thoughts turned to clothes."[216]

Matilda added millinery to her dressmaking shop, importing materials and trim from New York. She quickly outgrew her small space, rented the store to a jeweler and set up in a new, larger store. Matilda's store boomed, so much so that in 1877 when her husband returned from the Black Hills, he let her keep the shop open. Good thing, too, because he'd returned with very little fortune, save for a couple of ponies his sons kept as pets.

So Matilda ran her shop, and Charles ran his flour mill and brickyard and farmed land. He invested heavily in various properties in Fargo, and Matilda "advised her husband's cousin, S.G. Roberts, to buy the lots that he did and they became downtown Fargo."[217] They had hired a Swedish nanny to watch their three boys.

During down years in farming, Matilda's shop helped tide the family over when income was reduced. (Charles tried to provide for his family but got involved in a few risky business ventures. His mill burned down twice, though he rebuilt it. He also invested in Fargo's failed streetcar system, as well as the Sanborn, Cooperstown and Turtle Mountain Railroad.) Matilda eventually sold her dressmaking shop but took to selling sewing machines instead.

During the winter of 1881, Matilda took her three small sons to California to escape the Dakota winter. Charles joined them for a time, and soon trips to the West Coast became regular for the Roberts family.[218]

Adding Architect to Her Résumé

Despite Charles's risky business ventures, he did create a comfortable living for his family. Comfortable enough, in fact, that Matilda decided they should build a grand home for their family.

> *She chose one of their best lots, 519 Eighth St. S, and drew the plans for a 20-room house, a mansion it was called those days. Mrs. Roberts was her own architect. She had everything just as she wanted it; the only expense was having her plans redrawn to scale and having the blueprints made, which cost $25. Mrs. Roberts superintended the building herself.*[219]

Matilda used yellow bricks from her husband's brickyard and made the exterior as impressive as the interior. Built in Italianate style, the home had a mansard roof and several gables. Inside, the mansion had spacious rooms, a reception hall, a parlor, a sitting room, a dining room and a library; thick carpets covered the floors and mahogany furniture filled the rooms. Matilda included eight fireplaces topped by marble mantelpieces.[220] The second floor housed all the bedrooms for the Roberts family members, while the third floor offered a spacious ballroom. The basement was an activity area for the children.

The home was impressive, and deliberately so; Matilda planned it "as a showplace appropriate to Fargo's rising expectations and her family's status in a booming new town."[221]

In 1893, Matilda Roberts designed her own home at 607 Eighth Street South. The brick came from her husband's brickyard. *Author's collection.*

With the help of her sons, Matilda lathed all twenty rooms, hammering them about an inch apart so the plaster in the walls would stick. Charles was impressed "and even more amazed than usual at his practical wife."[222] The Roberts family threw a huge housewarming party, complete with dancing and card playing; nearly two hundred people were entertained that night.[223]

Matilda was happy. She was homeschooling her sons, and the family was living comfortably off rent from the most coveted residences of Fargo. Yet Charles was restless, and a railroad project in Wyoming beckoned. So he set off yet again, and Matilda stayed. And waited.

THE LEGEND OF FARGO'S PIONEER MOTHER

In 1903, Matilda had to temporarily sell her mansion when Charles was offered a contract to provide all the cement for the city of Minneapolis.[224] Matilda was torn—how could she leave the house she literally built with her own hands? With a heavy heart, Matilda agreed, knowing she'd at least get the chance to care for her aging parents. She rented the mansion as a

sanitarium, disposing first of its furniture, but after several years, the Roberts family came back to Fargo, restless for the open expanse of North Dakota and the friendliness of its people. Matilda tried to save her beloved home, but she couldn't afford to keep it or find a buyer to purchase it; she had to let it go. Matilda and Charlie lived in a small house until his death in 1925; she then moved in with her bachelor son, Willie.

In Matilda's later years, she became something of a legend. Affectionately referred to as "Grandma Roberts," "Fargo's first mother" or "Fargo's grand old lady," Matilda was revered for her pioneering prowess. On her eighty-sixth birthday, the *Forum* published a letter from then-mayor Alf Lynner congratulating her on a life well lived and the reminder of "the great many worthwhile things that can be included in one span of life." He continued: "Fargo is proud of the fine contributions you have made to its growth and of the lessons you have taught us. We of the younger generation are enjoying the fruits of your labor. May God lengthen out your days that we may celebrate with you more of your birthday anniversaries."[225]

Alanson Edwards's daughter, Marie Belknap, fondly recalled Matilda as the woman who built the "Big House," as it was referred to by the Eighth Street neighborhood. Marie liked to stop by Matilda's house on the way to school because "she had such thrilling tales to tell of pioneer days, of Indians, and of Mr. Roberts, our miller….She was never too busy to go to the sick or needy, and would travel long distances, day or night, to give them care."[226] Even after Marie moved away, she continued to correspond with her treasured friend, Matilda, sending letters each month.

Matilda died at the age of ninety in 1934 after having shared her many memories from her pioneering days.

> *Mrs. Roberts' contribution to the community can never be measured because we have accepted her as a matter of course, but the occasion of her passing should be one to make us pause to revere the work of all pioneers—those builders who gave us a material heritage in a thriving city, and a spiritual heritage of faith, courage, perseverance and gratitude for adversities that make us grow and joys through which that growth is manifested.*[227]

Today, the mansion she lovingly created from nothing continues to grace Eighth Street South in Fargo, a testament to her dream and unwavering resilience. "She planted her roots deep in Fargo, suffering hardships, learning to be brave for the sake of her children, living to the heights of joy after the darkness of despair but thrilling to every moment of her vigorous life."[228]

The grand lady may be long gone, but her grand home remains. When the Roberts family moved to Minneapolis in 1900, she sold most of the furnishings and rented the house. Even when she returned, she couldn't buy it back, so it spent years as a sanitarium. Matilda sold it in 1910, and it became an alcohol treatment center, but ten years later, it became an apartment complex. However, in 1987, a couple purchased the home for $57,000 and restored it to its former glory.

Chapter 12

EDWARD DARROW

Fargo's First Doctor as Kind as He Was Talented

I f Matilda Roberts had been born a man, she probably would have become a doctor, following in her father's footsteps. But as a woman of that time, she settled for studying her father's medical books and serving as a midwife once she arrived on the dusty prairie of Fargo.

Edward McClaren Darrow, however, was destined to become a doctor from the moment he was born. His mother, Isabelle, was known as "the doctor of the neighborhood" and tended to many births with her "abundant courage."[229] His brother was also a doctor, and Edward would eventually become the father of three doctors and father-in-law to yet another. Quite the family pedigree.

FOLLOWING FOLKTALES

Edward's story started in Wisconsin, where he was raised. He enrolled at Rush Medical College of Chicago in 1874, graduating four years later. Armed with a shiny new medical degree, Dr. Darrow headed to Fargo, "lured by stories of the Red River Valley he'd heard from two friends."[230] He found a small office above a drugstore on the corner of Main Avenue and Fourth Street South and established the first medical practice in the new city. He had his work cut out for him.

Fargo was a new city full of people looking to build a better life for themselves, but sanitation was not exactly a top priority in that endeavor.

Unclean water sources meant residents came down with a variety of illnesses often. Typhoid constantly threatened the community, and railroad accidents happened frequently. The lack of adequate medical facilities meant Dr. Darrow found himself performing surgeries on kitchen tables.[231]

Dr. Darrow wouldn't even see a board of health established for seven years, but he quickly established himself as a "man of high principle and integrity."[232] That led to his appointment as the first superintendent of health for Dakota Territory, and he encountered his first true test in that role just months later when an epidemic of the infectious disease pleuro-pneumonia broke out among cattle in western North Dakota. Dr. Darrow investigated and directed people to quarantine the infected animals. Soon after, he called for containment by slaughtering them and burying or burning the bodies immediately. More than one hundred animals were killed, but owners were paid per head and the grazing land burned and plowed over.

Even though the experience involved animals, Dr. Darrow took it upon himself to create rules and regulations regarding disease and disinfection for people, publishing them in 1886.[233] Soon after, Governor Andrew Burke appointed Dr. Darrow surgeon general.

As a young man, Edward Darrow sent this photo of himself to his betrothed, Clara Dillon. *From the Forum of Fargo-Moorhead.*

As a physician, Dr. Darrow revered his profession and took it upon himself to care for his patients as though they were members of his own family; he viewed his abilities as a public trust.

To men like Edward M. Darrow society owes a debt that cannot be paid in mere fees....He might be regarded as a connecting link between the old-

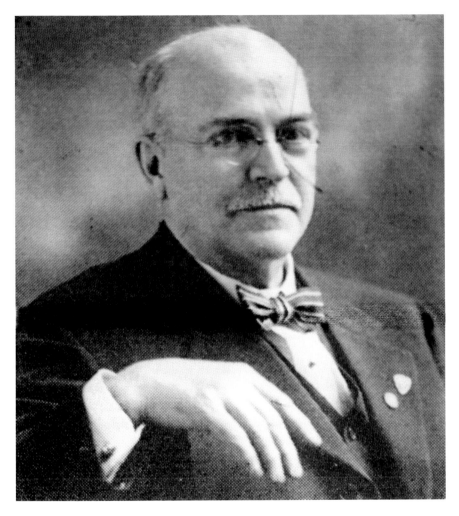

Dr. Edward Darrow was Fargo's first physician. He was the son of a physician, brother to a doctor and father of three doctors. *From the* Forum of Fargo-Moorhead.

fashioned family doctor and the modern scientific city surgeon. He was both. As a pioneer in Fargo and North Dakota, he took the deep personal interest in his patients that distinguished the old time family doctor of the small town. He was both physician and friend of most of his clients.[234]

As revered as Dr. Darrow was in the early Fargo community, he wasn't the only Darrow practicing in the area. His brother, Daniel Darrow, graduated from Rush Medical College as well and came to Moorhead,

where he opened a small hospital on what is now Concordia College campus. "The Darrow hospital was the first hospital in the area with a private room for surgery and the two brothers did all there [*sic*] surgery there practicing the newly learned techniques of sterile procedure."[235]

Speaking about his father years later, Dr. Kent Darrow talked about how he practiced without antibiotics, other drugs or the possibility of transfusions. He said that a surgeon "had to get in and out quickly and be a lot more delicate to cause as little bleeding as possible. My father was a beautiful surgeon—very delicate."[236]

DOCTOR RAISING DOCTORS

Dr. Darrow's first year in Fargo was spent alone, but he returned to Wisconsin to marry his college sweetheart, Clara Louise Dillon, whom he met while they both attended Lawrence University in Kansas (before he continued to medical school). They lived in an apartment until 1881, when Dr. Darrow built them a home at 714 Eighth Street South, which was a wheat field at the time. That's where Dr. Darrow and his wife would welcome five children: three boys and two girls.

In addition to demonstrating an astounding intellect, Dr. Darrow was a compassionate, kind healer. He had a "commanding presence" and was highly respected in his field, often providing diagnostic consultations to other doctors who sought him out.[237]

As a father, Dr. Darrow raised his children to be good people. His daughter Mary recalled that she and her father passed by the Fargo jail on one occasion, and the doctor told his daughter never to pass judgment on others for their actions. "You don't know what you would do yourself in certain circumstances," he told her.[238] That was just one way Dr. Darrow helped his family members embrace kindness and compassion. At home, learning and wit were emphasized.

All of these qualities emerged in a professional capacity when Dr. Darrow demonstrated inimitable comfort to those grieving. He was kind and approachable, honest and fair. He wanted to help whenever possible, and he sincerely cared for everyone who crossed his path; it was said that the death of a child would hit the doctor especially hard.

Perhaps that's why Dr. Darrow never stopped studying medicine. In the evenings, he would often ask his wife to read to him when his own eyes grew too weary. He often closed his eyes, and his wife would stop reading,

The family of Edward and Clara Darrow in 1905 included (*back row*) Kent, Mary and Frank and (*front row*) Daniel, Mrs. Darrow, Dr. Darrow and Elizabeth. *From the* Forum of Fargo-Moorhead.

Left: Dr. Frank Darrow was one of Dr. Edward Darrow's physician sons. He was a founder of the Dakota Clinic in 1925. *From the* Forum of Fargo-Moorhead.

Right: Dr. Kent Darrow was one of Dr. Edward Darrow's sons who founded the Dakota Clinic with his brother Frank and brother-in-law Ralph Weible. *From the* Forum of Fargo-Moorhead.

believing he'd fallen asleep. Yet Dr. Darrow would nudge her to continue and prove his attention by quoting the last sentence his wife had read. Other times, his daughter remembered, Dr. Darrow just wanted to sit and hold his wife's hand.[239]

That devotion to his wife was ever more evident after she died in 1915, and Dr. Darrow mourned her deeply. "His children say that he felt his loss the rest of his life."[240] It should be noted that the community felt Clara Darrow's loss too; she'd been active in the early feminist movement as one of the few college-educated women in Fargo when she arrived in 1879. Two years before her death, Clara was elected to head the local chapter of Votes for Women even though she was in California at the time. Mary hosted the gathering at the Darrow residence and carried on the fight for women's rights after her mother passed.[241]

Dr. Darrow's three sons—Kent, Frank and Daniel—all became doctors. They initially set up a practice called the E.M. Darrow clinic in the deLendrecie's building but began talking of founding their own clinic shortly after.

The Darrow family didn't stray too far away from their family's center. Son Kent lived just south of his parents' home, while daughter Mary, who married Dr. Ralph E. Weible in 1905, bought the home just north of the original Darrow home. Just north of the Weibles was son Frank and his family. Mary ended up moving back into her parents' home after they died, and she remained there after her own husband died in 1942. She eventually went to live with her son and his family.

LASTING LEGACY

Dr. Darrow died in 1919 of liver cancer, a swift death that gave him only a few months after diagnosis. Yet his dream of founding a clinic with his sons came to fruition, despite his absence. In 1926, Dakota Clinic was built at Seventh Street and First Avenue South; two other doctors joined the practice with Dr. Frank Darrow, Dr. Kent Darrow, Paul Burton (brother-in-law to Kent), Dr. Ralph Weible and a doctor named William Long.[242] The building the Darrow family set up practice in still stands; today it is the Sanford Neurology Clinic. In 1957, a new Dakota Clinic was built at 1702 South University in Fargo, with the Dakota Hospital being built adjacent to the clinic.

Though Edward Darrow died in 1919, his dream of opening a practice came to fruition when his sons opened Dakota Clinic in 1925 at 700 First Avenue South. *Author's collection.*

Dr. Darrow's death elicited many well-deserved tributes for a man whose own life touched so many. H.C. Plumley eulogized the doctor by saying, "Probably no man had ever been more beloved here, or had done more to relieve distress and make life more pleasant for those with whom he had come in contact."[243] Another public figure said, "He was gifted with an intellect given few men, his broad and generous knowledge extended to all departments of human activity....His studies and reflections covered every field....When word of his death came, a solemn hush passed over the entire city, in the homes of the rich and the poor many a silent tear was shed."[244]

Dr. Darrow's medical legacy lived on through his children. Dr. Kent Darrow ran the Dakota Clinic and then Dakota Hospital until his retirement in 1970. Dr. Frank Darrow was a successful doctor who retired in 1947 due to poor health before dying of stomach cancer in 1968. Dr. Daniel Darrow was a pediatric professor at Yale University and the University of Kansas School of Medicine before working for the Babies' Hospital in Wilmington, North Carolina, until his death in 1965. Mary and her husband, Dr. Ralph Weible, raised two doctors: Dr. Ralph Weible of the Dakota Clinic and Dr.

David Murray Weible of Clearwater, Florida.[245] Mary Weible, who earned a degree in chemistry from then NDAC, was honored with the NDSU Alumni Achievement Award in 1960 and again in 1963 when a new women's residence hall was named Weible Hall in her honor.[246] Dr. Darrow's legacy also lives on by serving as the namesake of many children who were named in "remembrance of the family doctor."[247]

Part VI
NDSU vs. UND

How the Rivalry Started

Note: Readers unfamiliar with the history of Fargo may be surprised to see a story specifically referencing North Dakota State University football. But those who have seen the masses form at the Fargodome or its predecessor, Dacotah Field, know that Bison football may be as integral to the community's identity as the Red River.

B uried in Henry Luke Bolley's personal correspondence files is a letter dated 1932 in which then North Dakota Agricultural College (NDAC) athletic director Casey Finnegan beseeched the former coach to recount how he founded the football program. No one else could do it. Bolley agreed, misremembering a few details but still chronicling a tale of toil and hardship in the first years of football at the AC. As a thank-you, Finnegan sent the former coach complimentary football tickets and continued to do so for many years.

Finnegan was right. No one was more able to recall how football came to the heartland than Bolley, who had made a name for himself as quarterback in 1889 at Purdue, one of the first universities to embrace the sport after it moved west from the East Coast. When Horace E. Stockbridge hired Bolley in 1890 as one of three faculty members at the newly established North Dakota Agricultural College, he probably didn't realize Bolley would contribute more than just his biology and zoology expertise.

After all, football was a new sport in Indiana, with a smattering of schools playing one another in a loose league. Despite the sport's newness, a heated rivalry sparked between Purdue and its neighbor college, Wabash. In a

particularly tense battle for a place in the state's 1889 championship game, Purdue prevailed in what was deemed a "slugging game" on Bolley's team photograph. The 1890 Wabash annual reported its school would have won "had she met true football players instead of 'foundry moulders.'" This impassioned contest laid the foundation for the NDSU-UND rivalry.

A NEWFOUND RIVALRY

When Bolley arrived in Fargo in 1890, he found an old Wabash rival, Melvin Amos Brannon, at the University of North Dakota (UND).[248] Bolley asserted that Brannon issued a challenge that the two institutions should continue the spirit of the Purdue-Wabash rivalry.

Brannon's football background is not known for certain, but he worked at UND as a biologist and eventually coached the UND football team, However, he was not hired until 1894 and did not serve as coach until 1897, when the coach at that time—Lieutenant Charles Farnsworth—was called back to military duty. In 1905, Brannon reported that he never played on any team while at Wabash and that from 1890 to 1894, he taught science at Fort Wayne High School in Indiana.

Given the strength of the support behind the football team at Wabash, Brannon must have gleaned his knowledge of the game from cheering on the team, not playing on it. In fact, Bolley scrawled, "I found my old friend and antagonist MABrannon" in his recollection;[249] perhaps Bolley referred to Brannon as an opponent simply because he knew Brannon graduated from Wabash. Perhaps Brannon was involved with the team in a coaching position.

No matter how the mix-up with dates and roles occurred, Bolley was right about a challenge being handed down in 1890 regarding a football contest. Despite Bolley's expertise with the sport, he spent the next three years scrounging up men from NDAC to contend with UND's team, which was established in 1892 and played only intra-squad games until the agricultural college could field a team.

Finally, in the fall of 1894, NDAC and UND met for the first time on a football field in Grand Forks. Neither team had enough men to fill the roster, so they each played a faculty member—NDAC played veterinary professor Theries Hinebauch, and UND played Farnsworth, their coach. Both instructors brought experience with them, as Hinebauch saw games at Purdue while he was teaching there; he also worked with Bolley at the

Left: Henry Luke Bolley was an accomplished professor at NDSU who also founded the first football team in 1894. *From the* Forum of Fargo-Moorhead.

Below: Members of the first North Dakota Agricultural College posed for a team photograph in 1894. In the back row is Coach H.L. Bolley. *University Archives, NDSU, Fargo.*

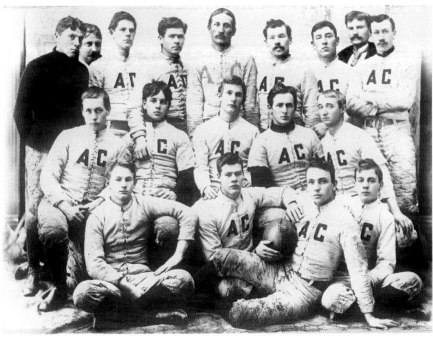

Experiment Station. In fact, just a few months after Bolley accepted his position at NDAC, Hinebauch accepted his. Farnsworth, on the other hand, had played football at the U.S. Military Academy and was credited as "the catalyst that led to the formation of a real football team" at UND.[250]

That first matchup resulted in an AC win, as the "farmers" defeated UND 20–4. Just a week later, the defeat was repeated in Fargo, but a controversy

about eligible players ignited the flames of a rivalry that burns today. In the second game, only NDAC played a faculty member, which "thereby gave some cause for the University to charge unfair tactics."[251] However, the local paper reported a different version of the second victory, citing that the "Grand Forks boys played their coach Moloney of Duluth, although the Fargo boys would have preferred to have observed the league rule, which provides that only undergraduates should play in college games."[252]

The *Grand Forks Herald* account tells yet a different tale: "The Fargo manager insisted on playing Professor Hinebaugh [*sic*], who may be classed as a professional player....[UND] Manager [Adolph] Bechdolt of the university eleven entered a vigorous protest but to no avail, and they finally played the game under protest, rather than be obliged to pay their own expenses."[253]

Because of the experience, the *Grand Forks Herald* speculated that it would be "some time before the two teams engage in another contest." Back then, the teams used ticket revenues to pay for railroad fares and entertainment; had UND pulled out of the second game in protest, the university would have incurred those costs.

Robert Reed, quarterback and captain for the 1894 AC team, confirmed that both teams were short players and used the aforementioned instructors to fill the roster.[254] Reed also said that when UND came to Fargo, they wore stocking caps while the AC team was bareheaded. By the end of the contest, the AC team had usurped the hats, and the university players "did not forgive us for a long time." Reed also reported that "the spirit of both cities was in the games between the AC and the U, and it was as much a Grand Forks and Fargo affair as it was a college affair."[255]

TURBULENCE ON THE PRAIRIE

Despite the *Herald*'s prediction, the teams continued to meet each year, with victories volleying between them. After 1895, a loose league formed between schools in South Dakota, Minnesota and North Dakota.[256] The contests between UND and the AC were "spirited, sturdy contests viewed with almost fighting enthusiasm by the public." The fighting enthusiasm most likely resulted from the bad feelings between the two schools that had become "a semi-permanent feature of athletic relationships of the two North Dakota colleges in the 1890s."[257] A lack of firm rules meant conflicts often arose, and the contests were poorly officiated, "bruising affairs, scarcely more than officially sanctioned gang fights."

In 1900, Bolley relinquished his title as football coach but retained his general manager position until 1909. At the turn of the century, former Minnesota quarterback Jack Harrison nurtured two successful teams that only lost one game. When Harrison left, Bolley solicited a Fargo lawyer named Henry Tweet to take over the team, but Tweet declined, citing his solo law practice as his reason for not committing to the team. Bolley ended up hiring Ed Cochems, who became the first official athletic director as well as coach.

Two extraordinary events were brewing. One came in the form of a new head coach, and the other was a disagreement that brought a temporary end to athletic relations between the two state institutions. After earning accolades as quarterback and end for the University of Minnesota, Gilmour Dobie served as assistant coach for two years before taking the reins at the AC. It was actually something of a fluke that Dobie was available to coach the NDAC team, as new conference rules dictated that coaches must be members of the teaching staff; Dobie was only an assistant. As director of athletics at NDAC, Dobie produced winning teams that never lost a contest under his direction. His teams were physically fit and used few substitutes, but a strong football following waned "as the victories came too easy."[258]

However, Dobie's philosophy and contributions to the program set a standard for AC football teams yet to step foot on the field. Dobie left after just two years as the only undefeated coach in the school's history, finding success as a football coach at the University of Washington, Cornell and Boston College.

Igniting the Flame

With already negative tensions smoldering between the two schools, it only took a spark to ignite the flames of rivalry that would burn for years.

First, a dispute over the exact definition and enforcement of a "professional" baseball player caused a rift in 1905. The next year, Brannon wrote Bolley a letter regarding a disagreement over a small fee that Brannon felt was not handled appropriately or fairly. That fall, UND suddenly cancelled the annual AC-UND game, infuriating fans and faculty alike. A November 29, 1906 *Fargo Forum and Daily Republican* article accused the university manager of having an "utter disregard for contracts and agreements." Brannon sent Bolley notification of the November 17 cancellation after 3:00 p.m. on November 16 because of inclement weather. Yet no other games had been cancelled due to weather conditions, so the

newspaper reported the action as suspicious, "considering the slight chance that [Brannon's] team seemed to have of winning against the A.C. team."[259]

By the next spring, UND had severed athletic ties with AC "in the interest of good fellowship."[260] The move was not news to NDAC though, as November 17, 1905 faculty meeting minutes show that members discussed the professionalism in the Grand Forks football team and left the matter of severing ties with the university up to the Board of Athletic Control if the other school would continue to "play proven professionals."

Athletic relations between the two state institutions resumed in 1910. NDAC lost, 0–18. During the next several decades, the two football teams would battle each other more than one hundred times. When NDSU moved to Division I in 2004, the rivalry appeared to be over. Yet the spark that had ignited the rivalry for more than one hundred years continues to burn and will likely do so now that UND will be rejoining NDSU in its conference in 2018.

THE FIRST RIVALRY PRIZE: THE PHELPS CUP

Before the Dakota Marker and even before the Nickel Trophy, UND and NDAC played for a different prize: the Phelps Cup. George H. Phelps was born in Virginia but arrived in the Dakota Territory in 1888, setting up a law partnership in Fargo. A football enthusiast, Phelps donated a trophy in the fall of 1899 to be awarded to the winner of the state championship. The institutions included in the competition were UND, NDAC, Wahpeton University, Fargo College, Moorhead Normal School, Valley City Normal School and Mayville Normal School.

Phelps laid out a set of rules to govern the trophy, such as that the teams must be composed of "actual and bona fide students" of the institution the player represented, that players who had been on the team for five consecutive years were not eligible, that every team eligible play each other in the season and that the winner of the cup would hold the trophy for a year until a new winner was determined.[261] However, if a team should win the trophy for three years in a row, it would retain the trophy as "absolute property."

After the AC won the championship in 1900, Phelps threw a banquet in honor of the team. The next year, the football team presented Phelps with "an elegantly framed picture of the Agricultural College football team."[262] No other records of the Phelps Cup being presented exist, and by 1937, the Nickel Trophy was used instead.

In 1910, Phelps moved to Bowbells, North Dakota. He died in 1928 in Minot.

THE MEN BEHIND THE MOVEMENT

HENRY BOLLEY, FOOTBALL FOUNDER

The youngest of twelve children, Henry Luke Bolley was born in 1865 in Manchester, Indiana. As a child, he enjoyed hunting and fishing, and when he enrolled at Purdue, Bolley made varsity in the three sports available: tennis, baseball and football. His achievements on the football field as quarterback on Purdue's first team equipped him with the skills necessary to found the football program at NDAC when he arrived in 1890 after earning his master's degree that same year. NDAC president Howard Stockbridge talked to Bolley about joining the staff, describing Fargo as the "biggest little city in the whole Northwest."[263]

Bolley quickly became an advocate for good sportsmanship and promoted involvement in football as a "great benefit to college life and to the future usefulness of the contestants as citizens."[264] Without Bolley, the natural rivalry between the two North Dakota schools might never have flourished. Because of him, "football took firm root in the new northwest and was soon played there as enthusiastically as if it were native to the region. Bolley was the man behind the institutionalization of football in North Dakota."[265]

Bolley's love of botany surfaced at a young age, and he began studying diseases of wheat and potatoes at Purdue under the direction of J.C. Arthur. He worked in the Indiana Experiment Station as assistant botanist and plant pathologist. (Stockbridge, who brought Bolley to NDAC, had served

as director of the Indiana Experiment Station before taking the presidency position at the North Dakota institution.)

Shortly after arriving in Fargo, Bolley met Frances Sheldon, a Fargo College faculty member. The couple married in 1896 and adopted a son, Don, and daughter, Ann. In 1903, the U.S. Department of Agriculture sent Bolley to Europe to continue his research there; his travels are documented in the NDSU Archives digital photo collection. The AC authorized a similar South American tour in 1930, so Bolley, his wife and his daughter Ann traveled to Argentina on a flax inspection trip. When Frances unexpectedly suffered two strokes and died in September 1930, Bolley brought her body back to Fargo[266] but returned to South America to finish his research by November. The next year, Bolley married Frances's sister-in-law, Emily Sheldon.

Throughout his time at NDAC and the Experiment Station, Bolley worked tirelessly on his botany and zoology research. One of his greatest contributions was solving the problem of flax wilt, which earned him international acclaim. He also made achievements in other agricultural issues of wheat smut, oats and barley, wheat and grain rust, potato scab and chemical control of weeds. To conduct his experiments, Bolley used "Plot 30," an eighth of an acre just west of campus that is now protected by the State Historical Society because of its storied use and contributions.

Purdue and NDAC awarded Bolley honorary doctorate degrees in 1938 and 1939, respectively. In 1944, Bolley's second wife died; he retired from teaching the next year. Bolley died eleven years later in Minneapolis at the age of ninety-one.[267]

MELVIN BRANNON, WORTHY OPPONENT

After Melvin Amos Brannon arrived at UND, he not only helped transform the football team but also made an indelible mark on the academic side. He taught biology for eleven years before being named dean of the Medical School in 1905. Brannon served as dean until 1911, when he was named dean of the College of Liberal Arts. He remained in that position for four years until taking a position as president of Beloit College in Wisconsin.[268]

For nine years, Brannon guided Beloit College through World War I and the adjustment after it ended. During his tenure, Brannon also founded an organization called Wisconsin Colleges Associated, which helped raise

money for state colleges to promote Christian education. In 1923, he took a job as chancellor of the University of Montana, where he spent ten years before retiring to Florida.

In a March 1950 article in the Wabash alumni magazine, Brannon was reported as still doing research on different plants in Florida waters despite his age of eighty-two; he had done his graduate work at Wabash on the same subject. That same month, Brannon passed away.

GILMOUR "GLOOMY GIL" DOBIE

In a letter to Henry Bolley about the possibility of Gilmour Dobie serving as the NDAC athletic director, University of Minnesota athletic director Henry Williams wrote that he "would be exceedingly sorry to lose Dobie, but there is no man who I could recommend so highly and feel sure that he would make an ideal man for you in the position of which you speak."

Eleven days later, Williams wrote an official letter of recommendation praising Dobie for his work on the football field as quarterback and field captain, explaining how Dobie "was one of the most brilliant and reliable quarters that I have ever seen." The players regarded Dobie with esteem and respect, Williams wrote. At the U of M, Dobie also ran track and played baseball and basketball. Williams described Dobie as "a man of good character," saying, "I shall miss Dobie very much as an assistant and shall be very sorry if he severs his connection with the University of Minnesota." Williams's glowing praises worked.

Despite an abundance of recommendations and inquiries about other potential athletic directors from colleges across the nation, Bolley hired Dobie as the athletic director, and the genial assistant flourished in Fargo. His manner and expertise endeared him to his players and earned their respect. During his two years at NDAC, Dobie nurtured undefeated football teams as well as successful men's and women's basketball teams.

By 1908, the University of Washington had lured him away, and during his nine seasons there, Dobie never lost a game.[269] He compiled a 58-0-3 record there that has yet to be surpassed. After leaving the AC, however, Dobie developed a gruff personality, earning him various nicknames such as "Gloomy Gil," the "Dour Dane" and the "Sad Scot." His success as a coach meant that most opponents resented him, though he never wavered in his tough regimen. Many of his players "simultaneously loved him, hated him, feared him and, at times, resented him."[270] No matter his personality or

his reputation with his players or his opponents, Dobie endeared himself to those who watched his games.

While at the University of Washington, he quickly became a source of pride, even being sung about in cheers. In December 1916, a conflict between the athletic and academic administrators resulted in Dobie's release as head coach. The public revolted and gathered outside Dobie's house to demonstrate their appreciation to Dobie. It didn't work. Dobie ended up at Navy from 1917 to 1919 before moving to Cornell in 1920. He coached three undefeated teams and received the first ten-year coaching contract.[271]

In 1927, Dobie's wife died, leaving him to raise three young children. In 1934, Cornell revised its entrance requirements, and Dobie experienced his first losing season ever. His 1935 team did not win a game. The next year, he was injured in a car accident from which he never fully recovered. He retired in 1938 after having coached at Boston College for three seasons.

For his football accomplishments, Dobie has been named member to several halls of fame. At Dobie's funeral in 1948, the reverend eulogized him as a great coach and father, describing his life as "the virtue of perfection in doing all things."[272]

This article originally appeared in the August 2010 issue of Bison Illustrated *magazine.*

Chapter 15

THE RAHJAH CLUB

Fueling the Rivalry

The haunted ballroom on the fourth floor of Minard Hall. The alleged death of a female student in Ceres Hall.

The notorious Rahjah Club.

Like any institution of a certain age, NDSU's history teems with tall tales, but one of those stories eclipses the rest…because it's true.

This story begins on the post–World War II campus at North Dakota Agricultural College. With the war behind them, veterans flooded the AC in increasing numbers, crowding sparse classroom space and straining overworked instructors. Fledgling athletic programs drew little support from the college campus or the larger community.

During the summer of 1948, Robert L. Owens decided to do something about it. "Owens was talking that summer about getting something going, a booster club to help some of the athletes," said Ed Graber, a 1949 NDAC graduate and former Alpha Tau Omega (ATO) member. "Bison athletics were in such doldrums at the time."

Owens, a 1949 NDAC graduate who passed away in January 2009, served as the president of Sigma Chi Fraternity, Blue Key Honor Society (then a fraternity), the Interfraternity Council and the junior class during his college tenure. He used his ties with the Greek community to elicit membership for the Rahjah Club, which he founded with the "purpose of perpetuating and promoting school spirit, which is an integral part of college life."[273]

Al Golberg, a good friend of Owens's and an ATO alum, served as secretary of the club during its first year at NDAC before he graduated in

1949. He explained that each fraternity supplied three members to the club, and the Co-op House and men's residences halls often had representatives. "We had a core then," Golberg said. "If you had a member from the fraternity who was motivating in his own group, it was kind of a seed."

Owens also spent time promoting the club's presence by visiting local radio stations. The group started out with only about a dozen members, and one of their first tasks involved creating a unified look through the purchase of jackets. The jackets would obviously be green and gold to honor the school, but a logo or emblem was needed to give the group purpose and identity. Who came up with the name Rahjah for the club is unclear, but Graber designed the emblem featuring a formidable genie rising from a bottle.

Rajah is a Hindu word meaning prince or ruler, and Graber fused the name with another staple in Indian culture that signifies power: the genie. "The Rahjah was a genie; it lent a helping hand," he explained. "It helped the team out of the bottle—it was the idea of helping the team." The jackets immediately stamped the group, and other students quickly took notice. "I guess we wanted to go to the games and be seen and get the student body to make some noise," Golberg said.

MAKING A NAME

As with most newly spawned student organizations, the Rahjah Club spent significant time fundraising and developing a rapport with campus. The group held a Rahjah Carnival with games and dancing to raise money, and members sponsored skits during halftime of the basketball games as inexpensive entertainment. Graber put his artistic skills to use again by designing a booster button that the club sold for fundraising. The Rahjahs also noticed the college athletic teams lacked cheerleaders, so a few members convinced a handful of gymnasts to take on the role. "They were the best cheerleaders in the league," Graber remembered. "We had the lousiest athletic teams but the best cheerleaders."

While raising money and fostering the Rahjah reputation were important, nothing served the group's purpose more than attending athletic events. Vern Skogen, a 1951 NDAC graduate and former Rahjah, said members always attended home games for football and basketball, clad in their green and gold duds. Skogen recalled one instance when NDAC was playing the university in Grand Forks and the Rahjahs couldn't get into the tiny gymnasium because UND students were being seated. Skogen said one guy

The Rahjah Club served as a pep club for athletic events at NDSU. *University Archives, NDSU, Fargo.*

got in, sat near a window and helped the rest of the gang climb in through the window.

It didn't take long for people to begin noticing the ostentatious group and their zealous antics. "We were pretty well accepted," Skogen said. "We weren't a big party group, and they were excited to have people cheering." The Rahjahs soon appeared in the homecoming parade and on the sidelines singing songs and generating support. The Rahjahs' role in cheering on the team grew larger when they began helping select the cheerleaders each year. Tryouts were held during basketball games, and Rahjahs helped select who made the squad.[274]

Permanent Bond

Becoming a Rahjah rested in exclusive invitations from current members. There weren't a lot of rules and paperwork once a person was nominated; most likely, the person would have fraternity brothers in the group already or

possibly know other fraternity members who were also Rahjahs. "It seemed like a worthwhile effort," Fred Brandt, an ATO alum and 1951 treasurer of the Rahjah Club, said of why he wanted to join. "We knew everybody." Brandt joined the Rahjah Club in its inaugural year with Ralph Christensen, who served as president of the group in 1951. Though Christensen passed away in 2000, his passion for the Rahjah Club lives on today, in the form of his cherished Rahjah jacket.

Robert Gjellstad, who was a Rahjah almost thirty years after Christensen, became friends with him before the elderly man died of cancer. Their shared bond from being Rahjahs led Christensen's family to give his jacket to Gjellstad. Gjellstad knew how much his friend treasured his time in the Rahjah Club, but when he opened up the box with the Rahjah jacket in it, he became acutely aware of how important the club had been to Christensen. "He took care of [that jacket] like a wife takes care of a wedding dress," Gjellstad explained. "It was in immaculate condition." Because Gjellstad already had his own Rahjah jacket as a memento, he saved Christensen's jacket for many years until deciding to donate it to the NDSU Archives, where it continues to be cared for and treasured.

SHOWING BISON PRIDE

During the year Christensen was president of the Rahjah Club, the group held an athletic banquet, awarded Outstanding Athlete of the Year honors, sponsored a Magic Carpet carnival and conducted an "elaborate introduction of the basketball team."[275] By the next year, the Rahjahs implemented another tradition by sponsoring a Sportsmanship Award in the UND-NDAC basketball series, explained Kenneth Roche, a 1952 pharmacy graduate. The group had local television and radio announcers pick a player in the series to receive the award, to ensure a fair process.

In keeping with its laissez-faire style, the Rahjahs met only once or twice a month, depending on necessity, and mainly discussed upcoming athletic events. Members convened at the old YMCA, located on the corner of University Drive and Twelfth Avenue. The efforts of the group to grow Bison spirit continued to receive a warm reception from campus. "The only thing I ever heard was good," Roche said of the club's reputation. "[Campus] was very supportive."

The Rahjahs didn't just support Bison athletics in Fargo. The group coordinated transportation to away games, especially in Grand Forks,

to ensure NDAC had fans outside their home turf. In addition to regular cheering from the stands, the Rahjahs also made noise using cowbells. "It got pretty rowdy when the University of North Dakota was down," said Monte Piper, the 1953 Rahjah president.

During the next few years, the Rahjahs padded their résumé even more by holding pep rallies, sponsoring a carnival and continuing to foster athletic support through exuberant cheering. The club also added a publicity director position to its roster of officers. In 1956, things got a little rowdier for the Rahjah Club when a group of UND students decided to form their own pep club to rival the NDAC group.

PRANKSTERS AND PREPSTERS

While the football rivalry between NDSU and UND is as storied as the institutions themselves, the Rahjah Club and the UND Golden Feathers elevated the competition in the mid-century with a multitude of "friendly" pranks. The Rahjah Club was founded in the fall of 1948, but the Golden Feathers didn't establish themselves as a group until 1956. The group's plans included awarding a trophy at the Colorado hockey series to the most valuable goalie and purchasing basketball outfits for the cheerleaders.[276] The Golden Feathers mirrored the Rahjahs in their purpose to "bolster lagging school spirit."[277] And, like the Rahjahs, members sported matching duds—black jackets emblazoned with golden feather patches.

While the Golden Feathers worked to establish themselves in Grand Forks, the Rahjahs continued their mission of promoting NDSU, mixing in a few pranks along the way. Jack Southam, the 1956 Rahjah president, doesn't remember the Golden Feathers, but he remembered a particularly funny story that happened up north at UND during the basketball series. "A number of students came to the game with sack lunches," recalled Southam, a 1956 NDAC pharmacy grad. "Except that at a specified time the sacks were opened and pigeons flew out of the sacks into the rafters. [UND officials] had to figure out how to catch those suckers." The Rahjah Club couldn't officially sanction the prank because the club wanted to avoid trouble, and only about a dozen birds were released. "It wasn't likely that we swamped the place," Southam laughed. "We had an awful lot of fun. I just think a group like the Rahjahs is good....I felt, at the time, that we were a good group and served the campus well."

The Rahjah Club was responsible for instituting a tradition of a homecoming bonfire. *Institute for Regional Studies, NDSU, Fargo (2098.s563).*

One of the biggest ways the Rahjahs served campus was through pep rallies before key games. Gene Gross, a 1957 graduate and former Rahjah president, recalled having pep rallies before football games and the Sioux-Bison basketball series. "We'd have a huge bonfire the night before the football game," he remembered excitedly. "The coaches were out there, the team....It was a real 'rah rah' situation....There was nothing better than beating the Sioux."

The enthusiasm Gross exhibited in explaining the Rahjahs' pep rallies is the same enthusiasm that led him to join the club in the first place. "I wasn't good enough to compete in athletics at that level," he said. "But I enjoyed athletics, and promoting them [through the club] meant

having a good time. It was a way to give a little back. It came naturally." During Gross's tenure, some fellow members were also active leaders on campus or in their respective fraternity. John "Tip" Miller served as the 1957 student body president while he was a Rahjah member, and Gross mentioned Gene Stockman and George Schwartz as other active campus and Rahjah members. "It was a pretty good group of people wanting to build school spirit," said Lowell Van Berkom, a former Rahjah treasurer and 1957 NDAC graduate.

Having such prestigious members meant that while the group always had fun, it still had a good reputation on campus. "I had my jacket up until two years ago....We wore that jacket proudly," Gross explained. "I never heard anything bad. Nobody came up to me and said, 'You guys are acting dumb.' It was clean fun....It was not a drinking club. We were like everybody on campus." Gross reminisced about spending football games huddled together at Dacotah Field, sipping peppermint schnapps to keep warm. "I never saw any outlandish activities," Gross said. "We never tried to harass anybody. We cheered more for our own team, not against the other team, although we didn't like the Sioux."

Van Berkom recalled trying to perpetuate some engagement from fans by instigating the fabled "stealing" ritual still honored today. The 1957 Bison annual states that the group tried to steal the SDSU cowbell, although Van Berkom couldn't recall the incident. He did remember trying to steal the Nickel Trophy. "We didn't get it," he laughed.

Even with the stealing and rowdy pep rallies, the Rahjah Club maintained a positive reputation on campus. "I thought it was an honor to be one of the people who helped promote the university, sportsmanship, cheering activity at the games," Van Berkom explained. "The recognition labeled you as someone who was a good supporter of the university."

Meanwhile, up in Grand Forks, the Feathers worked tirelessly to assert themselves on campus but still had only a loose organization set up by 1958. Two of their achievements in the organization's new life included awarding the Bill Borovsky trophy to the outstanding goalie in the league and establishing Sammy Sioux, a cartoonish mascot figure. The next year, the mascot's name changed to Sylvester Sioux.[278] The group also held a homecoming bonfire, just like the Rahjah Club.

Jack Simoneig belonged to the Rahjah Club from 1958 until 1960, when he served as president before graduating. He recalls how the rivalry between the two pep clubs led to the Rahjahs challenging the Golden Feathers in a hockey game. "They were the hockey guys, but we challenged their pep team

to a hockey game in Grand Forks," he remembered. "We made a big deal about it and we beat them....It was pretty interesting." Like Van Berkom, other Rahjahs also took great enjoyment in trying to steal the Nickel Trophy, which "brought a lot of spirit to the team," Simoneig said.

Throughout the early 1960s, the Rahjah Club continued to earn positive reviews from campus while still fostering a healthy rivalry with the Golden Feathers. Russ Maring, the 1963 Rahjah president, referred to the club as "a wonderful organization" and said its membership was composed of all the leaders on campus. One of his fellow Rahjahs, Sherwood Bassin, was the 1963 student body president. Harlynn Bjerke, another fellow 1963 Rahjah, reiterated the point, citing members who held positions in the Student Senate and Blue Key Honor Fraternity (now Society). "I think at that time we had a positive reputation," he said.

The club also initiated new traditions in 1963 that included selecting a small squad of Pom-Pom girls[279] and firing rockets at every Bison touchdown, a ritual still observed today. "We want to work for and with the University athletic department in any way we can to keep enthusiasm and pride in our athletic program," Rahjah president Dave Polluck said at the time. The club was working on getting a Bison mascot ready in time for homecoming and felt that a gymnast was desired for "the right effect."[280]

While it's unclear if the mascot debuted at homecoming in 1963, by 1964, a Bison mascot had been created. Gerry Clyne, a Rahjah member from 1962 to 1965, actually purchased the Bison costume for $105 from the same company that made the U of M gopher mascot outfit. "I called [the company] up and sent them pictures of buffalos, and they made me a costume," Clyne explained. "I wore it at a game, but after they realized I wasn't a gymnast, they decided that they would have a real gymnast." The Rahjah Club and the university eventually reimbursed him for the cost of the costume, and Jack Discher, a member of the gymnastics team, replaced Clyne in the costume.

Meanwhile, the Golden Feathers had begun ruffling a few feathers at UND. The group sometimes succeeded in bolstering athletic enthusiasm, but it often failed and was reprimanded for its shortcomings by campus critics. "Golden Feather was questioned by the Student Senate, by informal coffee gatherings in the Student Union and possibly most of all by a sports columnist in the campus newspaper."[281] While the yearbook implies the organization appreciated the publicity, the article also implies that the Feathers received the most publicity of any organization on campus on a weekly basis, though for what activities was unknown.

The next year, criticism of the Feathers heightened after the group missed two major basketball games and local sportswriters, fans and the UND athletic department promptly scolded them for the obvious absence. Like the Rahjahs, the Golden Feathers took the criticism in stride and continued on their mission of promoting athletics, donating a football and basketball scholarship and presenting the Bill Borovsky Memorial Trophy.

In Fargo, the Rahjah Club's seemingly positive reputation took a few hits. "[The Rahjahs] were supposed to be the wild bunch," Clyne said. "They were usually the biggest partiers in the [fraternity] houses. They had a wild reputation but did a lot of good on campus." The Rahjahs also continued to engage the Golden Feathers in prankish activities. Clyne recalled one incident where he and other fellow Rahjahs drove up to UND when a bonfire was happening, and they danced around it until a group of hockey players decided enough was enough. "They decided it was their job to see that we left, so they threw us in the coulee," Clyne remembered. "It was freezing over a little, so we broke a little ice when we went in, but we deserved it."

The Golden Feathers continued to absorb criticism, although the group became flustered with a lack of constructive criticism hurled at the organization. In a November 20, 1964 *Dakota Student* article and the 1965 Dacotah annual, then-Feather president Keith Magnuson said, "Golden Feathers has been criticized for doing a poor job. However, no one will give us suggestions for improvement. Adverse criticism is always easier than praising."

By the late 1960s, unrest had settled into many college campuses across the country. UND and NDSU (NDAC changed its name in 1960) were no different. With unrest came unruly behavior and changing attitudes. The Rahjah Club and the Golden Feathers evolved along with many other organizations, but both seemed to take a turn for the worse. It wouldn't be long before the groups disappeared completely.

DISCIPLINARY ACTIONS

Throughout the 1960s, many young people eschewed traditional values as a way to disassociate themselves. NDAC had recently changed its name to NDSU, and the Rahjah Club grew more and more zealous in its enthusiasm for Bison athletics. "We were a very fun-loving, spirited organization," laughed Al Selleck, a Rahjah member from 1966 to 1970. "We never got the respect we deserved. Blue Key was considered a very conservative group, but we Rahjahs had a lot of fun."

By the end of the 1970s, the Rahjah Club at NDSU was pretty much defunct. *University Archives, NDSU, Fargo.*

The group must have had a little too much fun, because in the fall of 1967, the Student Senate imposed a short probation for the Rahjah Club.[282] Complaints likely prompted this action, though "probation won't restrict their actions, but further complaints by students, faculty or townspeople could lead to the suspension of the club." Donald "Pepper" Walstad was serving as president of the Rahjah Club at the time of the probation. "We were pretty much on probation all the time, but student government formally put us on then," Walstad explained. The Rahjahs tried to "clean up [their] act a little bit" following the probation charge, Walstad remembered, wearing white shirts and ties to games with their infamous jackets. "We were much more well behaved in public and on campus," Walstad said. "But we didn't change our ways too much."

Following another boisterous display of enthusiasm at a football game, Walstad was called in to meet with the dean of students. He negotiated that the Rahjah Club would donate an amount of money to the new fieldhouse (now the Sanford Health Athletic Complex) being built on campus. "It was the only way we could stay on campus," he said. The Rahjah Club ended up being one of only two student organizations

that donated money to the fieldhouse fund, the other being the highly regarded Blue Key Honor Society.

The group's attempt to behave better in public didn't stifle their shenanigans with the Golden Feathers, though. Selleck recalled that the Feathers owned an immobile hearse with a painted yellow feather that was used in parades and pep rallies. "Well, we borrowed their hearse," Selleck explained. "We towed it down to Fargo and around campus in an impromptu pep rally. The Golden Feathers called and demanded it back, or we'd be charged with grand theft. So we towed it back and gave it to them."

Criticism Abounds

Both Walstad and Selleck attested to the friendly competition between the two rival pep clubs, citing other instances of harmless tomfoolery such as competing in a softball game against each other or referring to the Feathers as the "Golden Bananas." That moniker made its way north, as a 1967 Dacotah annual article refers to the UND organization as such. The article also states the group attempted to give itself a facelift to improve its "tarnished" image by working with the athletic department.

Apparently, while the Rahjah Club was getting in trouble for showing too much spirit, the Golden Feathers were accused of not showing enough spirit. A September 1967 *Dakota Student* article explains the criticism the group received from football fans, as well as charges the organization was biased in its selection process. A month later, an article in the *Dakota Student* questioned whether the group actually promoted school spirit, citing several—mostly negative—student comments about the organization. A 1968 Dacotah annual alluded to the criticism the organization received, as well as mentioned the Feathers' sponsorship of the King Kold Karnival. Little did anyone know that this event would play a significant role in the organization's undoing later on.

While most of the pranks the two clubs pulled on each other seemed relatively harmless, one incident in the fall of 1968 threatened criminal charges. During homecoming in the fall of 1968, about six thousand copies of NDSU's student newspaper, the *Spectrum*, disappeared from newsstands, stolen by two young men posing as the regular distributors.[283] Because of the $1,300 printing cost, authorities considered the theft grand larceny.

Fingers immediately pointed to the Golden Feathers, who'd been in Fargo the previous night "engaging in traditional initiation competition with their

NDSU counterparts, the Rahjahs."[284] A member of the Golden Feathers was discovered in an "NDSU fraternity house and his head was shaved. It was thought the Feathers might have chosen to retaliate by stealing the papers."[285] The UND dean of men and Golden Feathers president were notified. The organization's president discussed the matter with members who assured the authorities that the group was innocent.

But the bad press didn't end there. The Golden Feathers had been partially released from a $1,500 debt from the King Kold Karnival the previous February.[286] The Student Activities Committee loaned the organization the money but received nothing in return. Because the event only cost the club $1,100, SAC forgave that amount, requiring the return of the $400 difference. That payment proved troublesome for the organization.

In February 1969, a question was raised as to whether the Rahjah Club's controversial reputation was deserved.[287] The club's president acknowledged that members liked to drink but also pointed out the club's philanthropic activities, such as a pep queen contest, donating money to cheerleaders for uniforms, sponsoring a trophy for Little International and contributing money toward the fieldhouse fund.

One of the group's biggest supporters was Charles "Chuck" Bentson, dean of men, who boasted about the group's improved appearance and desire for a favorable reputation. The club also continued to tout several campus and Greek life leaders, said Mike Warner, a Rahjah Club member from 1969 to 1972. Much of the flak the organization fielded stemmed more from a cultural shift than actual actions from the club, he explained. "Just in general, kids were getting more of a reputation of being non-conventional," Warner said. "At the time, that was the brush that all college men got painted with—the cliché of college guys doing a lot of drinking."

One of the most notorious events in NDSU's history was Zip to Zap, an idea that originated among *Spectrum* editors to vacation to Zap, North Dakota, for spring break. The article was picked up by the Associated Press and spread across the nation, resulting in thousands of college students descending on the small town of Zap; the North Dakota National Guard was called in to dissipate the crowd when it became too unruly to control, and everyone was forced to leave. Sure enough, the Rahjahs and Feathers were involved. Or at least they were supposed to be. An athletic challenge between the Rahjahs and Golden Feathers was supposed to take place, but thanks to the debacle, the event never occurred.

By the end of the 1960s, the two pep clubs had already endured a roller coaster reputation. That wasn't soon to change. Warner also mentioned that

the preconceived notion society holds about college students—that everyone drinks—contributed to the club's blemished reputation, whether warranted or not. Suddenly, the university began disassociating itself from men's clubs and Greek houses in an effort to avoid liability issues, Warner said. Combine this with the feminist movement occurring throughout the country, and the wheels were set in motion for the undoing of the Rahjah Club.

THE BEGINNING OF THE END

In the fall of 1970, the UND Student Policies Committee revoked the Golden Feathers' constitution, refusing to consider a new one before second semester.[288] Three sororities complained that Golden Feathers members had harassed them. The organization's president said the small contingent of Feathers involved weren't active members but had been at a party for newly initiated members where alcohol was available.

The group's constitution was reinstated the following fall. Members were making a concerted effort to change the drinking image most people held about them through more acute selection and documenting procedures and attempting to raise money to repay the debt still haunting the group.

The group had actually changed its name to UND Feathers and had shed the old black and gold coats for green and white ones.[289] Despite the Feathers' name change and attempt to shed a stained reputation, the two organizations continued to maintain their friendly rivalry. "A lot of times [we'd] get together at Frenchy's Bar and plan an event," said Bruce Klabunde, a Rahjah member from 1975 to 1978. "There were some personality conflicts. There was always drinking involved and events can get out of hand."

While the relationship between the two groups maintained a "friendly" feel, tensions between each organization and its campus athletic department seemed to escalate. In January 1976, Rahjah member Roger Gress was arrested in Grand Forks after an uncharacteristically violent brawl broke out between the Rahjahs and Golden Feathers. Apparently, Golden Feathers members paraded a wounded, papier-mâché bison during homecoming to taunt NDSU fans.[290] Gress, who was married and a Vietnam vet when he joined the organization, remembers traipsing through the bleachers down to the court to "defend the honor of NDSU." Because most of the brawlers involved had been drinking before the game, the incident escalated quickly, and Gress found himself taken away to jail and released after paying a portion of his bond.

Naturally, Gress was embarrassed by what happened, and he and his wife, who was a graduate student at NDSU at the time, decided it might be best for his academic future to step away from the Rahjah Club, though he maintains a fierce loyalty to the organization to this day. (Gress served as the executive director of the Fargo Park District until December 2016 and is just one example of the many Rahjah members who have led successful, meaningful lives despite their involvement in what was eventually considered an unsavory organization.) Gress exudes a youthful enthusiasm when talking about his short time in the Rahjah Club and has acknowledged repeatedly that the activities happening within the group would never be allowed today because of changing cultural values. "It was just good times that got carried away," he explained. "We were all good guys."

The next year, an incident involving a wayward alcohol bottle and an injured football fan sent the Rahjah Club into a downward spiral. A Rahjah member was blamed despite proclaimed and witnessed innocence; suddenly, Rahjah members themselves began questioning whether their existence on campus was necessary any longer.

Not to mention that Title IX—the legislation passed in 1972 requiring gender equity for boys and girls in federally funded educational programs—dictated that the historically all-male Rahjah Club suddenly open its doors to female members. "We weren't going to attract women," said Scott Malmberg, a Rahjah member from 1977 to 1978, the last full year of the club's existence on campus. "[The club] didn't have a nice reputation among women." Though the club did admit a couple of women to satisfy the Title IX requirement, Malmberg said the football game incident and the basketball game incident the year before dictated what needed to be done. "The members decided to just quietly go away," he explained. "To make people happy, it was best to disband. It wasn't right, but it was for the best." Though not active on campus, the Rahjah Club maintained organizational status until the spring of 1980, when it was deleted from the Recognized Student Organizations List by the Congress of Student Organizations.

Meanwhile, in Grand Forks, the Golden Feathers had been banned in 1977.[291] On the UND Archives website, the organization's entry states it was banned for financial reasons, most likely stemming from that pesky $400 King Kold Karnival debt that was never repaid.

Is the Rahjah Club Really Gone?

Like so many other mystical institutions, the death of the Rahjah Club was slow and alluring. Malmberg said some people didn't wear their jackets around campus anymore to disassociate themselves from the smeared organization. "But we still cheered, still went to games," he said. "We weren't visible as a bunch, but we were still together with the same guys....We just became a student section." Malmberg said it best when he mused that the Rahjah legend is still alive and true today.

The Rahjah Club gave NDSU its first taste of student-led support, which continues today in the Bison Ambassador student organization. And the "pre-game drinking" that led to some of the infamous—and unfortunate—incidents the Rahjah Club is remembered for is reminiscent of tailgating that now takes place just west of the Fargodome before home football games.

And the song sung by a vast majority of NDSU students that begins, "On the plains of North Dakota standing there for all to see..."?

That's the brainchild of Rahjah member Ralph Peterson and a few of his fellow Rahjahs.

Note: This article originally appeared as a series in the August, September and October 2009 issues of Bison Illustrated *magazine. More than thirty people were interviewed, and some were asked about things that happened more than fifty years ago. This article was written as accurately as possible based on those interviews, archived documents and* Spectrum *articles.*

JOHN HAGGART

Lawman and Ag College Advocate

For as much as the North Dakota State Bison football team has done to bring notoriety and esteem to the institution as well as the community, the college would not have found its home in Fargo if it hadn't been for the tireless efforts of John E. Haggart, one of the first settlers of the area.

Haggart came from New York, where he lived on his family farm and was educated in country schools until he was seventeen years old. That's when he took a government job working construction, eventually serving with the Union army during the Civil War. He went home for a while, but in 1867, he headed west, landing in Kansas, Colorado, New Mexico and Wyoming. By 1871, he ended up in Dakota Territory and staked a claim on land along the Sheyenne River, just west of Fargo.

Soon after, he met a Norwegian immigrant named Birgit "Betsy" Hertsgaard and married her in 1875. She'd come to the United States in 1869 with her mother, three brothers and three sisters; she moved to Fargo and began waiting tables at the Headquarters Hotel. Together, they raised nine children on the farm west of Fargo. The Haggarts were popular members of the community's social circle and developed close friendships with other famous settlers like Samuel Roberts, Jasper Chapin, O.J. deLendrecie and Solomon Comstock.

As Haggart's political influence grew, he was frequently away from home, so Mrs. Haggart served as disciplinarian for the large family; even when he was home, the tender-hearted Haggart often deferred his children to "the doctor," aka Mrs. Haggart.[292] Despite her stern demeanor, Mrs. Haggart

John Haggart was a state legislator who introduced the legislation that proposed the state's agricultural college be placed in Fargo. *From the* Forum of Fargo-Moorhead.

had a good sense of humor, and the Haggarts frequently took their children on trips to St. Paul or simply to the Fargo Opera House to see various artists. Mrs. Haggart also preferred that her children bring their friends to the Haggart home rather than roam around elsewhere, so the house was frequently the site of gatherings where hospitality was "displayed that the visitors often remarked upon when they met Mrs. Haggart many years later."[293]

In 1874, Haggart was elected the first sheriff of Cass County, a position he would retain for twelve years. He was elected to the state senate in 1889, and he didn't vacate his position until 1898, when he accepted the role of U.S. marshal for the state of North Dakota. Even though Haggart worked as a law enforcement agent, he famously never carried a gun but could put "many a man down" with "a cuff delivered by his powerful hands."[294] He had no fear, using his powerful appearance to his advantage when dealing with roughnecks and ruffians. "He was as necessary to the frontier as the settlers who broke and tilled the lands."[295] Haggart's strength was legendary, as he was more than six feet tall and weighed nearly three hundred pounds. He was frequently called on to bring order to various situations, whether he was serving as a lawman or not. "Big as he was, John was quick on his feet, and when he moved forward, hard customers broke away and scattered."[296]

As if Haggart didn't do enough, he was also an early Fargo firefighter and was lauded for his courage and ability. "The story of John Haggart as an early Fargo fire fighter is virtually a history of the great fires of the city, from bucket brigade days on to 'the great conflagration' of June 7, 1893."[297]

He was named captain of the first fire company, called the No. 1 Hards (named for the wheat North Dakota became known for). He fought several fires in 1880, including the one that set the *Fargo Republican* (Major Alanson Edwards's newspaper) ablaze, directing other firefighters in their efforts. By the time the fire of 1893 hit downtown Fargo, Haggart knew the city's capabilities and equipment would not suffice to down the blaze.

He telephoned his farm on the Sheyenne and asked that the men bring all the teams and wagons available. They soon arrived and assisted in evacuating families and moving goods. Haggart and his men carried many children and invalids to upper stories to safety, and he found time to visit his family with messages of reassurance as the fire raged. He brought a number of refugees into his home.[298]

Haggart made a comfortable life for his family, and he was constantly aware of those less fortunate than him. On his farm, Haggart planted a potato patch and posted a sign encouraging the homeless to help themselves. When he found out that a widow had lost her cow because the court took it as payment for her late husband's debts, Haggart purchased the cow and returned it to the woman. At Christmas, he gave police officers twenty dollars in gold pieces. Perhaps that's how he was voted "most popular man in Fargo" in 1880.[299]

Considering all that Haggart achieved in his life, perhaps his greatest contribution was introducing an education bill that would establish an agricultural college and experiment station in Fargo. North Dakota became a state on November 2, 1889, thus earning eligibility for the Morrill Act that guaranteed at least ninety thousand acres of federal land to be sold to raise money for a land-grant college intended for the study of agriculture and mechanical arts. By January, the first state legislature convened, and Senator Haggart introduced a senate bill to establish thirteen institutes for the various cities in the state.

Bismarck was to have the capital [it also had the penitentiary, but the article tactfully omitted any mention of that fact], *Grand Forks the university, Fargo the agricultural college, Jamestown the hospital for the insane, Mayville and Valley City normal schools, Mandan a reform school, Wahpeton a school of science, Ellendale an industrial school, Devils Lake a school for the deaf and dumb, Pembina County a school for the blind, Lisbon an old soldiers' home, and some place in Rolette, Ward, McHenry, or Bottineau counties a school of forestry.*[300]

Even though the burden of that many institutions would challenge the young state, the bill passed, and by January 1891, the first students were accepted to the college. "It was Hon. John Haggart's acquaintance, popularity, and persistence in the legislature which gave [the agricultural college] the section of land and the appropriation at that time for its construction."[301]

Haggart's résumé included many different careers—sheriff, marshal, senator, as well as lumberyard operator, firefighter and soldier. He also served for a time as director of the Fargo and Southern Railroad as well as the Fargo and St. Louis Air Line Railroad Company. The résumé also included horse dealer. Haggart dabbled in the industry for a while, declaring he would never ride in an automobile. He was especially proud of the Abdullahs he raised, and he kept a beautiful pair as his own team. He frequently rode about town in a two-seat carriage or sleigh pulled by his prized ponies.

One of the long dramas of Haggart's life involved his older brother, Gilbert, who went missing in 1866. He came upon a traveling show whose wrestler challenged anyone to a duel, and the strapping young Gilbert accepted. His grip was so strong that he broke the wrestler's leg and feared the repercussions of his actions, so he headed west. Haggart spent fourteen years wondering where his brother might have been, but to no avail. While he was attending a trial, Haggart was told that a man in Tombstone, Arizona, was associated with a Gilbert Haggart. Haggart wrote to him immediately and learned the man was indeed his brother. When the two were reunited in March 1880, Haggart learned that his brother had fortunately survived Apache attacks in Arizona during his time away from Dakota Territory.

After living such a fulfilling life, Haggart died suddenly on September 22, 1905, at the age of fifty-nine, "leaving behind a multitude of friends heart broken and sorrowing at what seemed, in that first hot grief, his untimely taking."[302] His funeral was held in the Masonic temple, as he was the first Mason made in North Dakota, a Mason of the Royal Arch, a Knight Templar, 32nd degreed Scottish Rite Mason and member of Ancient Accepted Order of the Nobles of the Mystic Shrine. Haggart's Masonic involvement was important to him; he had seldom missed a meeting. "A man of the strictest

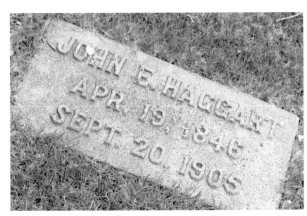

John Haggart's death in 1905 was unexpected. The business community of Fargo honored him by shutting their doors on the day of his funeral. *Author's collection.*

143

integrity and honestly, and of unusual ability, John E. Haggart was, withal, a man of so kindly and generous a disposition that to meet him was to know him and to know him was to love him."[303]

Flags were lowered to half-mast out of respect for Haggart, and many businesses closed their doors on the day of his funeral. He was buried at Riverside Cemetery in Fargo after a procession of sixteen carriages led them to the site. His beloved wife would live without him for another thirty-four years.

Before West Fargo was named that, the little town west of Fargo was called Sheyenne Crossing and then Haggartville or Haggart around 1884 as tribute to its illustrious resident. By 1931, West Fargo incorporated, and six years later, a small community southwest of Fargo also incorporated as well. In 1974, West Fargo became the West Fargo Industrial Park and eventually Riverside; the other community became West Fargo. Finally, in 1989, Riverside and West Fargo consolidated and retained the name West Fargo.

Part VII

Fun Facts

DIVORCE CAPITAL OF AMERICA

Reno may be known as the Divorce Capital of America now, but before the turn of the twentieth century, that dubious honor belonged to an upstart little midwestern community called Fargo.

The shenanigans started back in 1866 when the territorial government passed a law allowing anyone to begin the divorce process as soon as he or she arrived in the territory. Eleven years later, a three-month residency was established, but the divorcées didn't have to be U.S. citizens.

The loose residency laws in North Dakota meant any unhappy man or woman could travel to Fargo, rent a hotel room for ninety short days and be granted a divorce. Many people didn't even stay in Fargo; they simply left a bag and their hotel room fees and returned toward the end of the three months. The Northern Pacific train stopped at noon for ten minutes so travelers could get lunch; many would-be divorcées used those minutes to pay for a room, drop off a bag and get back on the train. The stop notoriously became known as the "Ten-Minute Divorce."[304]

Fargo not only had loose residency laws but also an influx of lawyers, and those attorneys knew they had the upper hand in assisting unhappily married men and women. There are tales that some lawyers inflated their rates for particularly desperate or wealthy people. The most anyone ever paid a local lawyer for securing a divorce is believed to be $10,000.[305]

One Fargo attorney was approached and asked for help in securing a divorce, but the man was worried about being robbed. The attorney told him he would "accept as a fee whatever the divorce was worth to the client." Yet ten days passed once the divorce was granted before the attorney heard

anything or saw any payment. Out of the blue, the client called the attorney to make payment and handed the lawyer a roll of twenty-five $100 bills.[306]

Fargo's free-and-easy divorce climate attracted a variety of clients and provided a substantial economic engine. People came from across the United States as well as Canada to get a quickie divorce, and they often dropped a significant amount of cash in the process. Actors, writers, socialites, British aristocrats and even clergy members flocked to the community to "sever their marriage ties and freely spent their money to do so."[307]

To provide some context to Fargo's divorce mill, consider this: during the same time, the state of New York only allowed divorce in the case of adultery. Other states allowed a person to sue for physical and economical separation, but not marital. South Carolina forbade divorce completely.[308]

One divorce tale involves an "Irish queen" from Dublin, Ireland, who came to Fargo with her brother. While waiting the ninety days for her divorce, the pair spent money lavishly. Things took an interesting turn when a gentleman from Kentucky took an interest in the "queen" and began calling on her. When her brother discovered the situation, a fight ensued, and the police arrested her brother for causing the incident. During the trial, the truth of the situation emerged—he was not her brother, but her lover, and had flown into a jealous rage when another man took interest in her.[309]

At one point, a young lady from New York traveled to Fargo with her mother to get a divorce. A lawyer agreed to help for $250 without realizing the woman was a niece of Chauncey Depew, the infamous attorney for railroad magnate Cornelius Vanderbilt. When he had to travel to New York to meet with her soon-to-be ex-husband, the lawyer discovered that the husband's attorney would receive a cool $1,500 for little more than an hour's work.[310]

While official records for the number of divorces granted are slight, one judge granted 350 divorces himself. Estimates indicate Cass County District Court averaged about 1 divorce each day and that the revenue from the divorce mill totaled $100,000, a significant sum for that period.[311]

As the tewntieth century loomed, certain Fargo residents took issue with the lax divorce law and sought to make a significant change. Bishop John Shanley of the Catholic diocese and the Woman's Christian Temperance Union (WCTU) were instrumental in changing the loose divorce law. Shanley saw the law as detrimental to the morality of North Dakotans, so he lobbied hard to have it changed in 1897, but to no avail. For the next session, Shanley rallied groups like the WCTU to apply pressure to lawmakers.[312]

It worked. In 1899, Governor Fred Fancher signed a new divorce law that required people to have lived in North Dakota for at least a year and be U.S. citizens.

SMITH STIMMEL

Lincoln's Bodyguard Buried in Fargo Cemetery

R iverside Cemetery is Fargo's oldest home to the deceased, and as such, the grounds serve as the final resting place for many of the pioneers who built the city—Major Alanson Edwards, Martin Hector, Ed Clapp, John Haggart, Isaac Herbst and many others.

Standing among their stone tributes is a squat, square headstone emblazoned "Stimmel." Nearby is a flat marble marker: Smith Stimmel 1843–1935. Much of the lettering has worn away, obscuring his birthdate. A man with two last names, it sounds. A man whose four family members rest nearby, as well as an additional marker labeled "Virginia."

This mysterious man is not one of Fargo's founders. But he boasted a prestigious pedigree no less. Stimmel served as a member of President Abraham Lincoln's military bodyguard for two years; the elite group included only one hundred men carefully selected from across the country. Later in life, he was also elected mayor of Carthage, Ohio, before landing in Fargo to practice law; he became a political leader and renowned speaker.

THE EARLY YEARS

Originally from Lockburn, Ohio, Stimmel was a farmer before entering military service. His father farmed land just a few miles south of Columbus, and Stimmel and his two brothers attended high school in Columbus (though

their early education was conducted in a country school).[313] That's when Stimmel first encountered President Lincoln.

Lincoln was en route to Washington, D.C., from Illinois when he made a stop in Columbus in February 1861. Just a teen, Stimmel recognized the importance of having the president stop in the city, and when school was dismissed to allow the students to hear Lincoln speak, Stimmel tried to get as close to Lincoln as he was able.[314] Lincoln's speech was brief but made an impression on the young Stimmel. Lincoln offered "generous words" about his competitor (Senator Stephen Douglas) and hoped he would receive the "same cordial greeting" from the people of Columbus.[315] To see Lincoln was to "feel closely drawn to him," Stimmel wrote, and he realized Lincoln was "preeminently a man of the people."[316]

As a teenager, Stimmel spent time in the heavily wooded area surrounding his family farm and became a skilled marksman, often supplying the dinner table with wild game. Stimmel's father expanded his family operation in 1857 but unfortunately died shortly after, on Stimmel's fifteenth birthday, no less. His mother, two brothers and Stimmel took on the additional farmland and worked to pay off the mortgage.

VOLUNTEER FOR SERVICE

At the onset of the Civil War in 1862, Ohio governor David Tod called for volunteers for a three-month service. Stimmel got permission from his mother and enlisted in the Eighty-Eighth Ohio Volunteer Infantry as a private. After completion, Stimmel enrolled at Ohio Wesleyan University in Delaware but was only able to complete one year.[317]

As the war continued, fears about security grew. Governor Tod convinced the president that he needed additional protection. The governor called for a volunteer from each of Ohio's eighty-eight counties for "highly honorable and strictly confidential service."[318] Stimmel decided to reenlist, and he soon became

As a young man, Smith Stimmel served as a personal bodyguard to Abraham Lincoln. *Scott Valentine.*

one of one hundred "splendid men" of the Union Light Guard.[319] Those individuals were tasked with the responsibility to "guard the entrance to the White House grounds, and to act as an escort to the President, whenever he went out in his carriage on horseback."[320] Stimmel himself often accompanied President Lincoln on his frequent late-night walks from the White House to the War Department.

Stimmel appreciated his two years of service to the president because it was an "opportunity to see a good deal of the everyday life of the President," including his devotion to his family.[321] Tad, that lively little chap, kept the White House full of mischief, while Mrs. Lincoln took great interest in her husband's welfare.[322]

Lincoln's devotion was never more evident than after the White House livery was set ablaze and several horses were lost. Lincoln wept after learning one of the ponies that had been lost belonged to his beloved son, Willie, who had died two years before. The "loss of the ponies brought back anew the sorrow he had experienced in the taking away of his little son."[323]

LINCOLN IS ASSASSINATED

Stimmel wasn't at Ford's Theatre in April 1865. No bodyguard was; Lincoln wouldn't have it.[324] "President Lincoln flatly refused to have a military guard with him when he went to places of entertainment or to church in the city. He said that when he went to such places he wanted to go as free and unencumbered as other people, and there was no military guard with him the night of his assassination."

Stimmel and the other members of Lincoln's guard actually weren't surprised the president was assassinated; they were only surprised it took as long as it did. The capital was crawling with "Southern sympathizers," not to mention the city was easy enough for men beyond the Rebel lines to enter. Stimmel was at home, asleep, on the fateful April evening when John Wilkes Booth fired a bullet into Lincoln's head.

> *It seemed to me that I had just gotten into a sound sleep, when I thought I heard someone calling my name from the outside of the building... The man who called said hastily, "Lincoln and Seward have been killed."... If I had been struck a stunning blow in the face I could not have been more dazed than I was for a moment on receiving that announcement.*[325]

As he and the other bodyguards raced to the theater, no one spoke—because "it was too horrible."[326]

It was an awful night. To be awakened out of a sound sleep and to be brought face to face with a tragedy so shocking made it hard for me to realize that it could be true. All night I rode slowly up and down the street in front of that house. Sometimes it seemed to me like an awful nightmare, and that I must be dreaming; sometimes I would pinch myself and wonder if I was really awake and on duty, so hard was it for me to realize the fact that President Lincoln was lying in that house in a dying condition.[327]

The guards hustled to the White House, surprised to discover Lincoln wasn't there. They headed toward the theater and cleared the area of civilians before standing guard outside Peterson House, where the president had been taken as. They were released around 7:00 a.m., and Stimmel learned a few hours later that the president had passed away twenty minutes after the guards left.[328]

After Lincoln's death, Stimmel discovered he didn't care much for President Andrew Johnson, so he requested a discharge and left the guard on

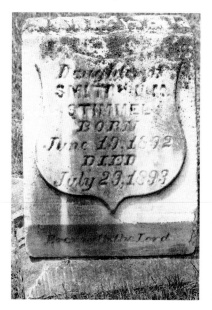

August 9, 1865. Stimmel jumped back into his education, reenrolling at Ohio Wesleyan and graduating in 1869. During the next year, Stimmel earned a degree from Cincinnati Law School, married Narcissa Margaret "Maggie" Goode and set up a law practice in the city of Carthage outside Cincinnati.

Stimmel's political career began budding, and he was elected mayor of Carthage. Suddenly, Stimmel set his sights on Dakota Territory, so he uprooted his wife and their two young children and moved to Fargo in 1882. He quickly set up a law practice, but by 1883, he had accepted an opportunity to manage a large farm near Casselton.[329]

He continued his political career in Fargo by being elected to represent rural Cass County in the territorial

Smith Stimmel and his wife, Margaret, lost an infant daughter in 1893. *Author's collection.*

legislature in 1888; his popularity soared, and he was elected president of the council. His term was short-lived, though, when the council was dissolved after North Dakota earned statehood in 1889.[330]

Stimmel returned to his farm, but his popularity as a speaker soared, so he left farming to return to his law practice (though he still retained ownership of farmland and real estate in Fargo and Casselton). Thanks to his personal relationship with Lincoln, Stimmel received a special appointment from Governor Louis B. Hanna to present a bust of Lincoln to Norway as a gift.

Back in Fargo, Stimmel's popularity soared. In 1921, Stimmel headed up area Memorial Day services. By 1922, he had retired from his law practice so he could travel and speak more about his Civil War experiences and relationship with Lincoln.[331] He published his memoirs about the Union Light Guard in 1928.

When Stimmel died in 1935 at the age of ninety-two, he was the last surviving member of Lincoln's bodyguard. Ironically, Stimmel's death on April 14 happened exactly seventy years after the death of his hero.

STIMMEL'S LEGACY

In addition to Stimmel's own book, other works have kept alive the memory of him and his affiliation with Lincoln. M. Elizabeth Perley wrote a book in 1935 called *The Last of the Bodyguards: Smith Stimmel*, and his youngest son, Howard Lincoln Stimmel, wrote a play called *Through My Father's Eyes* in which he performed the role of his father.[332]

In 2007, Stimmel's grandson LeRoy Fladseth visited Fargo to pay respects to his grandfather in his final resting place at Riverside. Fladseth never knew his grandfather, but he kept his memory alive by republishing Stimmel's book in 1997. Themes such as patriotism, faith and respect for fellow man that ran through Lincoln's work also were present in Stimmel's writings and speeches, Fladseth said.[333]

Stimmel was not the only one of Lincoln's bodyguard to publish personal reminiscences of the sixteenth president, but "Stimmel's up-close-and-personal memoir provides us with stories that would otherwise be untold."[334]

While many early works focus on Lincoln the politician, Lincoln the president, and Lincoln the commander in chief, Stimmel's work largely illustrates the ordinary aspects of Lincoln's life. Stories about the president's interactions with his children, a fire in the White House stable, and his

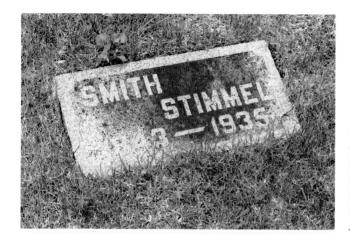

Smith Stimmel died on April 15, 1935—seventy years after his idol, Abraham Lincoln. Stimmel is buried at Riverside Cemetery in Fargo. *Author's collection.*

plain and simple manner captivate the reader as they personify Lincoln as an average American.[335]

Thanks to his straightforward description of President Lincoln, Stimmel offered great insight into a man largely considered one of the greatest presidents in history. "The American people owe a debt of gratitude to the memory of Abraham Lincoln that they can never pay, for I verily believe, the fact that we are a united people today is, under God, due to Mr. Lincoln's marvelous wisdom and sagacity in directing the affairs of state during those perilous times."[336]

Stimmel's time spent serving at Lincoln's side had a profound impact on him and would continue to do so for the remainder of his life. "To the end of my life I shall be grateful for the Providence which gave me such glimpses of one of earth's grandest heroes, one of her noblest martyrs, one of the finest specimens of manhood which God has ever produced: Abraham Lincoln, patriot, statesman, gentleman."[337]

THE CRYSTAL BALLROOM

The Legend Lives On in Fargo

In the mid-twentieth century, the hottest place in Fargo was the Crystal Ballroom. Back then, a squat brick building stood on the corner of First Avenue South and Broadway that had been built in 1913 by the City of Fargo for $200,000. The first floor housed the National Guard armory, with a municipal auditorium on the second floor. That's why the building was alternatively called the Fargo Armory and Fargo Auditorium. In 1929, the Crystal Ballroom took up residence on the second floor, its expansive wooden floors soon to welcome the finest dancers in Fargo, as well as the most well-known musical acts of the time. But not just musical entertainment. The venue was the hot spot for any large event—meetings, clinics, programs, conventions, demonstrations, recitals, banquets, tournaments, weddings and even a circus or two.[338]

The mastermind behind the ballroom was R.E. "Doc" Chinn, a National Ballroom Operator Association president who operated the ballroom from its first day. A focal point of the ballroom was the crystal ball hanging from the ceiling, a decoration Chinn made by adhering glass fragments to a large globe while sitting at his kitchen table, his daughter Sheila Schafer said in a 2014 *Forum* article.[339] Chinn was responsible for booking the musical legends who graced the ballroom stage: Louis Armstrong, Les Brown, Lawrence Welk, Gene Krupa, Carlos Molina, Fats Waller, Eddie Duchin and Tommy Dorsey.

At a time when racial segregation was a daily occurrence, Schafer remembered that some African American performers had trouble finding hotels at which to stay after the performance. Schafer said her father set up cots for Armstrong and his band members to sleep in the ballroom after their show was over and the place cleared out.[340] Armstrong even came over

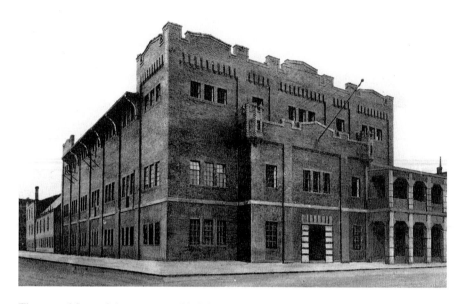

The second floor of the armory at Sixth Street and First Avenue South was home to a dance hall called the Crystal Ballroom. *Institute for Regional Studies, NDSU, Fargo.*

to the Chinn house for supper, even though Schafer's mother had no idea who their dinner guest was or how famous a musician he would become.

One of the most memorable acts in the storied history of the Crystal Ballroom was Duke Ellington. The jazz legend was on a meteoric rise to stardom when he booked a performance at the Fargo in November 1940. Two South Dakota State College (now University) alums named Richard Burris and Jack Towers found out about Ellington's concert and contacted the William Morris Agency in New York for permission to record the event.[341] They had no idea that the recording they would make that cold November night would end up being one of the most significant pieces of Ellington's musical legacy.

Duke himself was a bit baffled by the request to record the Fargo concert, but he agreed to it. Burris and Towers set up, the orchestra warmed up the crowd and then Ellington sat down at his piano. Burris and Towers hit the record button. "They were on, baby. Stanley Dance, freelance writer and longtime Ellington friend, says the recording captured an evening when the orchestra was hitting all the notes."[342]

Burris and Towers weren't thinking about the legacy the recording would have; they simply wanted to capture the music of one of the industry's greatest performers. Once the recording was made, though, Burris and Towers could never profit commercially, per an agreement with the agency.

But things happen. One dubbed tape was passed to someone, who passed it to someone else…and so on and so on. In 1964, the bootlegged recording even popped up in Europe.[343] In 1978, the recording was officially released as *Duke Ellington at Fargo, 1940 Live* and won the Grammy for Best Jazz Instrumental Performance, Big Band. Schafer was a fifteen-year-old when Ellington played in the famous ballroom. She was one of about seven hundred people who filled the ballroom, and she ended up with a recording of that concert.

It should come as no surprise that the Duke Ellington concert is still synonymous with the historic Crystal Ballroom nearly eighty years after it took place. Photos from the concert (as well as other important ballroom events) were featured in a scrapbook Chinn kept throughout the ballroom's lifetime.

That scrapbook—"as square as a card table and thick as four Manhattan phone books"—chronicled the many talents whose names are etched in the ballroom's history.[344] Also included in the scrapbook were snapshots of happy couples who met and fell in love in his ballroom, as well as the adorable babies who resulted from those unions.

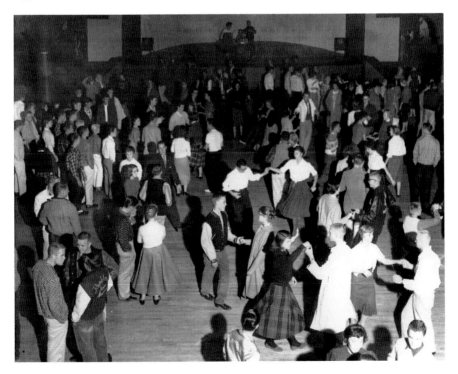

In the 1950s, the Crystal Ballroom served as a social hall where weekly dances drew large crowds. *Institute for Regional Studies, NDSU, Fargo (2092.116.16).*

Dorothy Bangert Bacheller from Santa Barbara, California, wrote a letter to the North Dakota Institute of Regional Studies in 1998 recalling a few times she was "lucky" enough to go dancing. She remembered a Mrs. Sanders, who vetted patrons to make sure they were dressed appropriately and sober enough to dance. Bacheller even said she was asked to remove a wide-brimmed hat because Sanders thought it might hide bad behavior. Bacheller complied immediately because "one did not defy Mrs. Sanders."[345]

As much fun as the ballroom was on Saturday nights, it was still a lot of work. On Sundays after church, Chinn and his daughters would go to the ballroom so he could begin sweeping up the remnants of the previous night's concert and the girls could have a little fun—they'd turn on the crystal ball and chase the moving lights.[346]

The ballroom's downfall was liquor. Booze was illegal in dance halls, so people who wanted to imbibe had to find a different location in which to do so. Attendance declined at the ballroom. Performers booked elsewhere. The city (which still owned the building) decided to raze the building, demolishing a significant piece of Fargo's history.

Before the building was razed, Chinn reflected on his days as the ballroom operator with fondness and a healthy dose of hindsight: "If a kid asked for my advice, I'd say, 'Go to school and learn. Learn anything. Get smart. Then do anything in the world, but don't open a ballroom.'"[347]

Not everyone heeded that advice. Schafer said her father gave "Mr. Leslie [of Ramada Plaza Suites] one of the records of Duke Ellington."[348] That Mr. Leslie is Robert Leslie, the developer behind many of Fargo's most successful hotels and real estate companies. Back in 1996, Leslie opened the Ramada Plaza Suites & Conference Center south of Thirteenth Avenue. Just a year later, a $4 million addition was built, with the centerpiece being a fifteen-thousand-square-foot gathering space large enough to fit 1,250 people.[349]

Leslie named the space the Crystal Ballroom. Leslie's son, Norm, who is president of the company his father created—National Hospitality Services—said most of the spaces in the Ramada have names with musical references, but the ballroom's name is a nod to the historic space that once graced downtown Fargo. "The tradition of having great musicians play in the Crystal Ballroom continues," Norm Leslie said. The Ellington recording is now in a case in the pre-function space of the ballroom.

Years after the ballroom's demolition in 1962, an apartment complex was built on that section of prime downtown real estate.

Its name?

Crystal Square.

AREA HISTORY LIVES ON
IN *FORUM* MORGUE FILES

A pair of shiny silver scissors sits nonchalantly on a shelf in a small, subway-tiled room. The blades are long—nearly nine inches—and razor-sharp.

These are the scissors your mother told you never to run with. They're a relic left from the days when ladies bent over inky newspaper pages, meticulously cutting, cataloguing and chronicling the people and topics mentioned in the area's regional newspaper.

The small room those knife-like scissors call home is the *Forum* library, or "morgue." Morgue files are the envelopes that contain clippings about people, places and things published in a newspaper. The morbid name is a newspaper term that emerged in the 1880s when articles and photos of particular people were collected and catalogued in case the biographical subject died suddenly and an obituary was needed; all pertinent information would be easily accessible.

The original work of creating a repository of information—and cataloguing all of it—fell to Andrea Hunter Halgrimson, a beloved longtime *Forum* employee who passed away in February 2015. For years, Halgrimson painstakingly created the library after inheriting an archival disaster. Files were not organized in chronological order. Biography files were mixed with subject files. Sticky zinc half-column plates for mug shots were jumbled with clippings. Halgrimson imposed order on chaos, and she added byline files to make it easier for writers to find articles they'd written.

The subject files in the *Forum* archives/library include articles about a wide range of topics. *Author's collection.*

In an age when most people associate information with the Internet, digitizing the *Forum* is a topic of constant discussion. Transferring the information contained within the newspaper is a costly endeavor and one Forum Communications Company will continue to consider as grants and projects like the Library of Congress's Chronicling America make it more feasible.

The resources available in the library include:

- Power File: The biggest Rolodex you've ever encountered. Except no contact information is provided because the folders simply contain every newspaper article that mentions a particular person for whatever reason. The file includes physical articles from 1922 to 1995; content published after 1995 has been archived electronically. Reporters frequently consult the Power File for background on business owners, anyone charged with a crime or well-known figures.
- Card Catalogue: Perhaps the last one still in existence anywhere…except the Library of Congress, perhaps. This tool helps individuals locate particular topics in the room, as well as related subjects.

- Oversize Files: An extension of the Power File, these overstuffed folders contain clippings about people whose names are published in the paper frequently, like elected officials, well-known business people and local celebrities.
- Microfilm Rolls: Square boxes containing rolls of micro-photocopied versions of the *Forum*, beginning in 1880. When stored and handled correctly, the shelf life of microfilm is more than five hundred years. *Fun fact*: Microfilm is printed on nitrate film, a highly explosive and flammable substance.
- Byline Cabinets: Filing cabinets filled with folders labeled with *Forum* employees who have written articles for the newspaper.
- Historic Mugs: Photos of famous people that have been taken by *Forum* photographers or gathered from the Associated Press.
- Miscellaneous: *Forum* indexes, historical documents, city directories (dating back to 1893), Who's Who in America, etc.

On a side wall in the library is a corkboard. On that corkboard is a nondescript postcard that asserts: "A great library contains the diary of the human race." In the case of the *Forum* library, it's not the entire human race—just the history of the Fargo-Moorhead community and anyone fortunate enough to pass through at some point in time.

NDSU ARCHIVES TREASURE-TROVE OF HIDDEN HISTORY

Any author of a book about the history of Fargo would be remiss not to mention the NDSU Archives and their instrumental role in providing information for the effort. Officially known as the Institute for Regional Studies, the archives are a vast trove of historical information about regional and genealogical history.

Established in 1950 by the faculty of the School of Applied Arts and Sciences at NDSU (then known as North Dakota Agricultural College), the institute was originally a project designed to preserve the past and help the future.[350] Space was carved out for the institute's collection on the second floor of the east end of the new college library.

The institute began building its collection immediately, with local residents donating items of historical value. Microfilm reproductions of old newspapers were also created. Within a couple of years, the institute had amassed a collection of nearly eight thousand early photos, several county histories, manuscripts, correspondences, rare newspapers and privately printed books.[351]

In 1955, the grandson of James Power, the Northern Pacific Railroad land commissioner who helped Fargo get on its feet, donated a collection of six thousand personal and official letters from the railroad mastermind.[352] In 1961, the institute acquired the records of the Amenia and Sharon Land Company, Herbert Chaffee's bonanza farming business.[353] In addition to collecting items, the institute also published various history books as well as poetry, plays and pamphlets.

By 1973, the institute's collection had grown large enough that its space was extended to one-fourth of the NDSU library basement, as well as a "sizable" room in another campus building.[354] However, many historical records were becoming available, forcing the institute's staff members to critically evaluate whether they could feasibly manage adding to the collection.

In October 1975, the institute celebrated its twenty-fifth anniversary with an open house and dedication program. For the next twenty-five years, the story remains much the same—collections grew, donations were accepted, the institute published important works.

Then, in 2000, heavy summer rains flooded the NDSU library, including the basement where the region's historical documents lived. Water crashed through the library's southside windows, flooding the first and lower level. Staff and a horde of volunteers went to work to save as much as possible.[355] Waterlogged materials were trucked to a document-drying center in Chicago, where they were freeze-dried before being disinfected and hand-cleaned with a dry chemical sponge.

Following the cleanup, the institute moved off-campus, to what was then called the Skills and Technology Training Center on Nineteenth Avenue

The Institute for Regional Studies and NDSU University Archives support research needs of North Dakota State University as well as the greater Fargo-Moorhead community. *Author's collection.*

North. Thirteen years later, the lease expired, and the institute found a new home at the NDSU storage annex at 3601 Seventh Avenue North. Some archived material had already been stored in the annex, so the move consolidated the institute's collections. Local historian Andrea Hunter Halgrimson wrote about the archive's move, noting that the institute is a "treasure house of the history of a region that includes the Red River Valley, the state of North Dakota, the plains and prairies of North America."[356]

The amount of information stored and carefully catalogued at the NDSU archives is astonishing. The staff are helpful and incredibly resourceful, no matter what project is at hand or inquiry presented to them. The collections include marriage records, pioneer biography records, census and naturalization records, photographs, obituaries, historical exhibits, Fargo city directories, postcard collections and local community histories.

Halgrimson said it best: "There is just no end to the fascinating information available in this amazing repository. A comfortable reading room and knowledgeable and helpful staff add to the pleasure of a visit. Plan a trip to the archives. They have something for everyone."[357]

FORUM REPORTERS TOLD EARLIEST HISTORICAL ACCOUNTS OF FARGO

The information used to write the stories contained within this book is only available to modern writers because years ago, individuals took it upon themselves to tell the stories first. They are the people who saw the value in recounting these tales from long ago, and their meticulous research is what makes modern publications like this still possible to write.

One of the most respected and prolific local history writers was Roy Paul Johnson, a man whose rejection by the U.S. Navy made his career as a reporter possible in the first place. Born in 1899 in Minnesota, Johnson volunteered for World War I, but his heart murmur resulted in rejection. He worked briefly on the railroad before coming to Fargo in 1919 as a Western Union telegrapher. Over the next three years, he worked for the Associated Press as a telegrapher in Iowa, Nebraska and South Dakota before returning to Fargo to work as the AP receiver for the *Forum*. His incredible typing skills made him an immediate asset to the state's largest newspaper, but in 1928, automatic teletype machines replaced telegraphy in transmission, so the *Forum* gave Johnson a reporting assignment instead.

Johnson took some journalism courses and became an invaluable reporter. Although he also honed his photography skills, his editors realized his true talent was telling stories about nearly every subject possible—movie reviews, crime, traffic court and many others. Johnson's reporting went on hiatus when he served in World War II, but he returned in 1946 and turned his reporting skills to historical work. Johnson's first foray into historical work was writing about General George Custer.

Once his interest was aroused, Johnson could not stop. A grand, new, fascinating world opened to him....One story led to another until he found himself collecting material on a dozen topics simultaneously....People sent him diaries of the old-timers or asked him to come and interview some person who could supply him with the information he wanted. Gradually, systematically, he acquired an enormous amount of data in the form of excerpts from books, Photostats of diaries, clippings, books, interviews, maps, photographs, and old newspapers.[358]

No topic was off limits, and Johnson enthusiastically tackled each one. And he wrote these historical accounts in a way that even people who said they didn't enjoy history would be intrigued. The public's appreciation for Johnson's work came in the form of numerous letters he received when the content was published.

Through his work, Johnson became acquainted with other historians and several organizations recognized him for his efforts. He served as historical advisor to the Dakota Territorial Centennial Commission in 1960. Three years later, Johnson passed away, leaving behind his wife, Mary. But his stories live on through the work he did and the stories he first told.

Many of those stories also fascinated Andrea Hunter Halgrimson, a Fargo native born in 1940 who became the *Forum*'s head librarian in 1972. Not only did Halgrimson enjoy recounting many new historical tales, but she also took it upon herself to create an organized and efficient archive. Using her library science degree from North Dakota State University, Halgrimson created order out of chaos. Her presence in the library was pervasive. "Like the newsroom library she ran for so many years, Andrea served as the less-formal-but-no-less-valuable institutional memory of our community and our newspaper," *Forum* editor Matthew Von Pinnon said.[359]

Halgrimson recounted various history stories through her "As I Recall" column, but she also shared her love of food and cooking through a column she began writing in 1987. As Halgrimson lovingly tended the files in the archives, she located history about her own family.

Then the future happened. In 1995, the *Forum* retired its clipping files— the morgue as described in Appendix A—and moved to an electronic archive. But Halgrimson soldiered on until her retirement in 2004. She was diagnosed with lung cancer and died in February 2015 from the illness. She was survived by her longtime partner, Sam Bernstein, and the newspaper clipping announcing her death was tucked away in one of the five-by-seven manila envelopes in the library that Halgrimson left as a legacy of her work.

Another *Forum* columnist, Curt Eriksmoen, has taken up the mantle Johnson and Halgrimson left behind. His "Did You Know That…?" series began in 2003 and covers a variety of historical topics involving the state of North Dakota.

The work of these three writers is invaluable to other individuals interested in local history. Their research makes it possible for those of us who want to continue sharing those stories. "Anyone who wants to write history for newspapers or for a book will be helped to some degree by being a little crazy. It isn't entirely necessary…but it helps.…Of course, it is best for the historian's peace of mind not to realize that other people think you are strange."[360]

NOTES

Chapter 1

1. *History of the Red River Valley* (Grand Forks, ND: Herald Printing Company, 1909), 485.
2. "1871 Brought First People: Land Company Sought to Baffle Settlers by Use of Ruses," unknown source, Institute for Regional Studies Collection. The site for Moorhead was selected at the highest point possible to keep the city safe from floods. By then, the area had already experienced significant floods in 1826, 1852 and 1861. The land had to be purchased from Joab Smith, a longtime settler who had lived on the Moorhead land site for years and ran the stage line. Andrew Holes was tasked with purchasing the land, but he had to walk at least part of the way to Alexandria, Minnesota, to file the appropriate paperwork.
3. Ibid.
4. W.M. Wemett, "Real Settlement of North Dakota Came With the Railroad," *Fargo Forum*, April 4, 1923.
5. "Pioneer Tells of Early Days: 'Wild and Wooly' West Not So Wild; Good Fellowship Prevailed," unknown source, Institute for Regional Studies Collection, 1928.
6. Kris Kerzman, "Throwback Thursday: Fargo Named for Railroad Tycoon on Valentine's Day in 1872," *Forum of Fargo-Moorhead*, February 11, 2016.
7. *History of the Red River Valley*, 488.

8. Roy P. Johnson, *Roy Johnson's Red River Valley* (Fargo, ND: Red River Valley Historical Society, 1982), 317.

9. Carroll Engelhardt, *Gateway to the Northern Plains: Railroads and the Birth of Fargo and Moorhead* (Minneapolis: University of Minnesota Press, 2007).

10. Ida May Owen, "Cold Fails to Break Their Spirit," *Fargo Forum*, February 18, 1930.

11. Roy P. Johnson, "Fargo Site Shunned Until ND Crosses the River," *Forum of Fargo-Moorhead*, June 4, 1950.

12. Ibid.

13. Ibid.

14. Ibid.

15. *History of the Red River Valley*, 509.

16. Fargo, North Dakota: Its History and Images, "Continental Hotel," accessed December 16, 2016, library.ndsu.edu/fargo-history/?q=content/continental-hotel-1880s.

17. *History of the Red River Valley*, 496.

18. Norene A. Roberts, *Fargo's Heritage* (Fargo, ND: Fargo Heritage Society, 1984).

19. Johnson, "Fargo Site Shunned."

20. Author unknown, "Fargo, N.D. The Gateway of the Red River Valley," source unknown, 1892.

21. "Fargo Abroad: Extracts from a Sparkling Letter in the St. Paul Globe—Our Growth and Prosperity," source unknown, January 21, 1880.

22. Clement Lounsberry, *Early History of North Dakota* (Washington, D.C.: Liberty Press, 1910), 565.

23. *History of the Red River Valley*, 504.

Chapter 2

24. *Fargo Forum*, "William G. Fargo Namesake for City," June 4, 1950.

25. Ibid.

26. H. Katherine Smith, "Memory of Express Pioneer Perpetuated in Street's Name," *Fargo Forum*, 1940.

27. *Fargo Forum*, "William G. Fargo Namesake for City."

28. Ibid., "While a Resident of Buffalo He Had Deep Interest in the West," January 18, 1927.

29. Ibid.

30. Ibid.

31. "Wm. G. Fargo, Pioneer Express Man, Gave Name to This Town," source unknown.

32. *Fargo Forum*, "Modernization Opens Small Chapter in Fargo History," December 29, 1963.

33. Ibid., "While a Resident of Buffalo He Had Deep Interest in the West."

34. Edward Hungerford, *Wells Fargo: Advancing the American Frontier* (New York: Random House, 1949), 61.

35. Western New York Heritage, "Fargo Mansion—Then & Now," accessed October 25, 2016, www.wnyheritagepress.org/content/fargo_ mansion_-_then_now/index.html.

36. Smith, "Memory of Express Pioneer."

37. Ibid.

38. Jacek A. Wysocki, "The Life and Times of William G. Fargo," *Western New York Heritage* 5, no. 3 (2002).

39. Smith, "Memory of Express Pioneer."

40. William G. Fargo, *Daily Argus*, August 6, 1881.

41. *Fargo Forum*, "Modernization Opens Small Chapter in Fargo History."

Chapter 3

42. Cullum's Register, "George W. Cass," accessed October 25, 2016, penelope.uchicago.edu/Thayer/E/Gazetteer/Places/America/United_ States/Army/USMA/Cullums_Register/665*.html.

43. Ibid.

Chapter 4

44. Lounsberry, *Early History of North Dakota*, 350.

45. Ibid.

46. Johnson, "Fargo Site Shunned."

47. Lounsberry, *Early History of North Dakota*, 351.

48. Eugene Virgil Smalley, *History of the Northern Pacific Railroad* (Los Angeles: HardPress Publishing, 2012), ch. 34.

49. Carroll L. Engelhardt, *Gateway to the Northern Plains: Railroads and the Birth of Fargo and Moorhead* (Minneapolis: University of Minnesota Press, 2007), 288.

50. *Forum*, Sunday, June 15, 1975. 7.

51. Barbara Ann Caron, "The James Hill House: Symbol of Status and Security," *Minnesota History*, 238.

52. Ibid.

53. Minnesota State Historical Society, "The Hill House," accessed October 23, 2016, sites.mnhs.org/historic-sites/james-j-hill-house/hill-house.

54. Ibid., "James J. Hill," accessed October 23, 2016, sites.mnhs.org/historic-sites/james-j-hill-house/james-j-hill.

55. Lounsberry, *Early History of North Dakota*, 351.

Chapter 5

56. O.G. Libby, *Collections of the State Historical Society of North Dakota*, vol. 3 (Bismarck: State Historical Society of North Dakota, 1910).

57. Wemett, "Real Settlement of North Dakota."

58. Hiram Drache, *The Day of the Bonanza* (n.p.: Interstate Publishers, 1964), 68.

59. Ibid.

60. Carole Butcher, "James B. Power," Dakota Datebook, accessed November 5, 2016, www.prairiepublic.org/radio/dakota-datebook?post=64340.

61. Drache, *Day of the Bonanza*, 69.

62. Wemett, "Real Settlement of North Dakota."

Chapter 6

63. Encyclopedia.com, "Bonanza Farms," accessed November 30, 2016, www.encyclopedia.com/history/encyclopedias-almanacs-transcripts-and-maps/bonanza-farms.

64. "Saved by Fargo: Settlers Save the N.P. Land Department," unknown source, n.d., from Institute for Regional Studies Collection.

65. Drache, *Day of the Bonanza*, 94.

66. John Stewart Dalrymple, "Oliver Dalrymple, the Story of a Bonanza Farmer," n.p., 1960.

67. *History of the Red River Valley*, 233.

68. Oliver Dalrymple letter, 1870.

69. Drache, *Day of the Bonanza*, 109.

70. Dalrymple, "Oliver Dalrymple."

71. Drache, *Day of the Bonanza*, 141.

72. Ibid., 143.

73. Ibid., 74.
74. Letter by Gertrude Bacon Chaffee, January 30, 1955.
75. Florence Chaffee ended up marrying John H. Reed, the son of Newton Reed of Amenia, and had two sons and a daughter. One of those sons, Robert Reed, came to North Dakota with his grandmother when he was twelve years old after his mother died five years earlier. In 1895, Reed became the first graduate of the North Dakota Agricultural College and a member of the first football team. Reed Hall on the North Dakota State University campus is named in his honor.
76. Drache, *Day of the Bonanza*, 148.
77. Ibid., 155.
78. Ibid., 157.
79. Ibid.
80. Tammy Swift, "A Titanic Life: North Dakota Bonanza Farmer Accomplished Much before He Perished at Sea," *Forum of Fargo-Moorhead*, April 8, 2012. Carrie Chaffee ended up on the same lifeboat as one of the most famous passengers: Madeline Astor. Her husband, John Jacob Astor, was the richest man on the *Titanic*. He did not survive. Carrie Chaffee returned to New York City aboard the *Carpathia* and met her son, Herbert Lawrence, and a son-in-law.
81. Drache, *Day of the Bonanza*, 92.
82. Ibid., 98.
83. Ibid., 103.
84. Ibid., 105.
85. Ibid., 106.
86. *History of the Red River Valley*, 347.
87. "Fargo Abroad: Extracts from a Sparkling Letter."
88. Dalrymple, "Oliver Dalrymple."
89. Drache, *Day of the Bonanza*.
90. *Minneapolis Journal*, "Must Be Broken Up: The Bonanza Farms of North Dakota and Their Ways," June 3, 1893.

Chapter 7

91. Personal recollections from Marie Belknap, 1950, Alanson W. Edwards Family Collection, Institute for Regional Studies, 8–9.
92. Frederick William Chapman, *The Trowbridge Family or Descendants of Thomas Trowbridge, One of the First Settlers of New Haven, Connecticut* (New

Haven, CT: Punderson, Cirsand, 1872), 142. Some sources list Alanson as the firstborn of five brothers, two of whom died young and unmarried. That account also indicated that Alanson was born in 1834, though every other existing record indicated 1840 as his date of birth. Also, a 1900 census record lists a brother named Henry living with the Edwards family in Fargo, though the Trowbridge family list includes brothers named Abner, George, Jonathan and Leander.

93. *Fargo Forum*, "Edwards Had Key Role in Founding Forum," Saturday, September 27, 2003.

94. Melva Moline, *The Forum: First Hundred Years* (Fargo, ND: Fargo Forum, n.d.), 6.

95. Ibid.

96. David Heinzmann, "Prison in Joliet Closing Its Doors after 144 Years," *Chicago Tribune*, February 15, 2002, articles.chicagotribune.com/2002-02-15/news/0202150063_1_stateville-correctional-center-maximum-security-prison-inmates. Though often referred to as the Illinois State Penitentiary in historical documents regarding Alanson Edwards, the Joliet prison was known as the Joliet Correctional Center. It was built to reduce overcrowding at Alton, which closed in 1860 as a state prison but became a military facility for housing Confederate prisoners and dissenters. Joliet Correctional Center received its first prisoners in 1858 and was closed after 144 years, in 2002, to trim millions from the state's budget.

97. Moline, *The Forum*, 7.

98. Chicago City Directory. Some people incorrectly believe Ashland Avenue was named after the Great Chicago Fire of 1871, but it was already an established suburban neighborhood by the time the fire broke out. The area was considered the height of suburban living in the 1860s, according to Alice Maggio, author of "Ashland Avenue, the Great Fire and the Ruins of Chicago," Gapers Block, June 23, 2005, gapersblock.com/airbags/archives/ashland_avenue_the_great_fire_and_the_ruins_of_chicago.

99. Moline, *The Forum*, 7.

100. Ibid.

101. Curtis Eriksmoen, "Fargo Printer Became Successful Promoter in ND," *Fargo Forum*, Sunday, June 17, 2012.

102. Moline, *The Forum*, 10.

103. Ibid., 11.

104. Ibid., 16.

105. Ibid. Joseph Medill is the famed *Chicago Tribune* editor for whom the Medill School of Journalism at Northwestern University is named. Medill

had been elected mayor of Chicago one month after the great fire, which is also when Edwards arrived in town. Encyclopedia Britannica, "Joseph Medill," March 4, 2016, www.britannica.com/biography/Joseph-Medill. Despite the support for a third term, Grant ended up losing the nomination to James Garfield on the thirty-sixth ballot. Scott Bomboy, "History Wouldn't Favor Third Term for Obama, or Most Presidents," Constitution Daily, July 28, 2015, blog.constitutioncenter.org/2015/07/history-wouldnt-favor-third-term-for-obama-or-most-presidents.

106. Moline, *The Forum*, 22.

107. Ibid., 49.

108. Ibid., 50.

109. *Fargo Forum and Daily Republican*, February 8, 1908, 1.

110. Moline, *The Forum*, 51.

111. *Fargo Forum*, "Edwards Had Key Role."

112. Moline, *The Forum*, 25.

113. *Fargo Forum*, "Edwards Had Key Role."

114. N.D. Press Association Hall of Fame, "Major Alanson W. Edwards," *North Dakota Press Bulletin* 23, no. 4 (n.d.): 3.

115. *Fargo Forum*, "Edwards Had Key Role."

116. Fargo, North Dakota: Its History and Images, "Fire of 1893," library, ndsu.edu/fargo-history/?q=content/fire-1893.

117. Moline, *The Forum*, 58.

118. Ibid., 59.

119. Personal recollections from John Palmer Edwards, 1950, Alanson W. Edwards Family Collection, Institute for Regional Studies, 8.

120. *Fargo Forum*, "Edwards Had Key Role."

121. Personal recollections from Marie Belknap, 3.

122. Ibid., 12.

123. Ibid., 14.

124. Ibid., 3.

125. Personal recollections from John Palmer Edwards, 8.

126. Ibid., 7.

127. Phil Matthews, "Fargo Chamber of Commerce Marking Its 100th Year," *Sunday Forum*, n.d., C-12.

128. Ibid.

129. Personal recollections from Marie Belknap, 3.

130. *Daily Argus*, July 26, 1888.

131. Forum Staff Reports, "Major A.W. Edwards: Big in Stature, Big in Influence," *Forum of Fargo-Moorhead*, Tuesday, November 14, 1978.

132. *Fargo Forum*, May 1, 1983.
133. Moline, *The Forum*, 78.
134. *History of Red River Valley*, 184.
135. Personal recollections from Marie Belknap, 9.
136. Ibid., 7.
137. Moline, *The Forum*, 80.
138. Personal recollections from Marie Belknap, 7.
139. Forum Staff Reports, "Major A.W. Edwards."

Chapter 8

140. City of Fargo, City Info, "A Brief Glimpse into Fargo's Early History," www.cityoffargo.com/CityInfo/FargoHistory.
141. 1891 City of Fargo Directory.
142. In 2016, during excavation of the parking lot, artifacts from around the Crystal Palace were extricated and provided to researchers and archaeologists to be studied and dated.
143. *Fargo Forum*, "Sin City," June 15, 1975, 6.
144. Ibid.
145. *Bismarck Daily Tribune*, "The City," June 5, 1901, 8.
146. *Jamestown Alert*, "Melvina's Finish," June 6, 1901.
147. Ibid., "Will Be Released," March 27, 1902.
148. *Fargo Forum and Daily Republican*, "Aged Negress Is Dead," May 4, 1911, 10.
149. Judith Florian, "The Meaning of 'Inmate' and 'Warden' in the 1700s to Early 1900s," History of and Other Families from the City and County of Washington Pennsylvania, freepages.genealogy.rootsweb.ancestry.com/~florian/genealogy101/g_101_meaning-of-inmate.htm.
150. Snopes.com, "Red Light District," www.snopes.com/language/colors/redlight.asp.

Chapter 9

151. Andrea Hunter Halgrimson, "Business Owner Was True Pioneer," *Fargo Forum*, March 1, 2008, B1. Elliott was born in Oswego, New York, but moved with his parents to St. Paul when he was four years old. He was educated at the Cathedral School in that city. Elliott's parents were Irish immigrants.

152. *Fargo Forum*, "Peter Elliott," March 8, 1928.

153. Ibid.

154. Ibid.

155. Halgrimson, "Business Owner Was True Pioneer," B1.

156. *Fargo Forum*, "Peter Elliott."

157. *Cass & Clay County Review*, "Elliott House and Restaurant," December 1, 1892.

158. Ibid.

159. Halgrimson, "Business Owner Was True Pioneer," B1.

160. *A Century Together: A History of Fargo, North Dakota and Moorhead, Minnesota*, "Fargo's Early Hotels," June 1975.

161. *Fargo Forum and Daily Republican*, "Elliott Hotel," July 19, 1907.

162. Halgrimson, "Business Owner Was True Pioneer," B1.

163. *Fargo Forum and Daily Republican*, "Elliott Hotel."

164. *Fargo Forum*, "Peter Elliott."

165. *Fargo Forum and Daily Republican*, "Elliott Hotel."

166. *Fargo Forum*, "Peter Elliott." Peter's brother John Elliott was with his brother in California when he died (so was Loretta's sister, Elizabeth).

167. *A Century Together*, "Fargo's Early Hotels."

168. Andrea Hunter Halgrimson, "Furnishing Old Broadway," *Forum*, Monday, August 1, 2011, C3.

169. *Forum*, "Kilbourne Group Gives Broadway's Loretta Block New Life," May 15, 2012, accessed July 30, 2016, www.inforum.com/content/kilbourne-group-gives-broadways-loretta-block-new-life.

170. Ibid.

171. According to U.S. Census records from 1925, J. Frank McKone was born on May 16, 1877, in Richmond, Indiana, but was raised in Ohio. At the time, he owned a home at 1449 Seventh Street South worth $8,500. They had one daughter named Mary, but the census record also lists a twenty-year-old Bertha Graham living in their home.

172. Marino Eccher, "Ghosts in the Stones," *Forum*, Saturday, November 13, 2010, C1.

173. F. Urban Powers was born on August 19, 1898, and died on March 10, 1980. He was the son of Thomas Powers, a construction tycoon whose company, T.F. Powers Co., continues to operate today. Francis Urban Powers attended school at St. Thomas Military Academy and the University of Minnesota. He worked on the East Coast for a while but returned to Fargo to manage the Fargoan in 1924. Soon after, he and his brothers formed the Powers Brothers Hotel Co., which controlled the

city's major hotels for the next forty years. Elizabeth Meade Elliott Powers graduated from St. Mary's of the Woods in Terre Haute, Indiana, and North Dakota Agricultural College (now North Dakota State University), where she was a member of Delta Phi Beta sorority. Elizabeth, who died on January 11, 1989, at the age of eighty-five, and her husband are buried at Holy Cross Cemetery in Fargo.

174. Eccher, "Ghosts in the Stones," C1.

Chapter 10

175. "Onesine Joassin deLendrecie," *History of the Red River Valley*, vol. 11, 1000.

176. Curt Eriksmoen, "O.J. deLendrecie's Merchant Legacy Lives On in Fargo," *Forum*, Sunday, July 22, 2014, C4.

177. *Fargo Forum*, "60th Year in Business Noted by deLendrecie's," October 22, 1939, 3-1.

178. Ibid.

179. Ibid., "O.J. D'Lendrecie, Founder of One of City's Great Stores, Is Dead," October 9, 1924.

180. *Fargo Forum*, "60th Year in Business," 3-1.

181. "Behold the Picture: An Imposing Structure Now in Course of Construction by O.J. deLendrecie Opposite the Argus Office," Institute for Regional Studies Collection.

182. *Fargo Forum*, "deLendrecie Needed Nerve to Build Store," November 3, 1929.

183. "Behold the Picture."

184. *Guide*, "Mrs. E.J. deLendrecie Recalls Early Days of Fargo, the City She's Loved Since 1900," March 1971, 9.

185. Ibid.

186. Ibid.

187. "Behold the Picture."

188. *Fargo Directory*, "O.J. De Landrecie," 1881. Reprinted in the *Fargo Forum* on April 14, 1935.

189. *Fargo Forum*, "O.J. D'Lendrecie, Founder of One of City's Great Stores."

190. Ibid., "60th Year in Business," 3-1.

191. "Onesine Joassin deLendrecie," *History of the Red River Valley*, vol. 11, 1000.

192. Eriksmoen, "O.J. deLendrecie's Merchant Legacy," C4.

193. *Fargo Forum*, "O.J. D'Lendrecie, Founder of One of City's Great Stores."

194. Ibid.

195. Ibid.

196. Ibid.

197. *Fargo Forum*, "deLendrecie Parking Lot Opened," August 25, 1962.

198. Ibid., "Two Fargo Buildings on Historic Register," November 11, 1979, E.

199. "Onesine Joassin deLendrecie," *History of the Red River Valley*, vol. 11, 1000.

200. *Fargo Forum*, "Two Fargo Buildings on Historic Register," E.

Chapter 11

201. Ibid., "'First Citizen' of City Passes Early Today at Age of 90 Years," n.d.

202. Ibid.

203. Ibid., "Hardships of Pioneers Told," January 18, 1929.

204. O.G. Libby, Collections of the State Historical Society, 1906, vol. 1.

205. *Fargo Forum*, "Hardships of Pioneers Told."

206. Doris Eastman, "Talented Mrs. CA Roberts Mansion's Designer," *Fargo Forum*, February 3, 1974.

207. Ida May Owen, "Beginning the Story of Fargo's Pioneer Mother, Matilda Roberts," *Fargo Forum*, February 17, 1930.

208. Ida May Owen, "Cold Fails to Break Their Spirit," *Fargo Forum*, February 18, 1930.

209. Ida May Owen, "Roberts' Fortunes at High Tide," source unknown, n.d.

210. Ibid.

211. Owen, "Beginning the Story."

212. Eastman, "Talented Mrs. CA Roberts."

213. Owen, "Roberts' Fortunes at High Tide."

214. *Fargo Forum*, "Hardships of Pioneers Told."

215. Owen, "Roberts' Fortunes at High Tide."

216. Ibid.

217. *Fargo Forum*, "Hardships of Pioneers Told."

218. Owen, "Roberts' Fortunes at High Tide."

219. Ibid.

220. Ibid.

221. Ibid.

222. Ibid.

223. *Fargo Forum*, "Food Was Not Plentiful So Parties Were Rarely Given," February 13, 1927.

224. Ida May Owen, "Fargo Rivals Reno in Early '90s," *Fargo Forum*, February 21, 1930, 12-2.

225. Ida May Owen, "And the Trail Ends for Charlie," *Fargo Forum*, February 22, 1930.

226. Personal recollections from Marie Belknap, 11.

227. *Fargo Forum*, "First Citizen," June 28, 1934.

228. Ibid., "Hardships of Pioneers Told."

Chapter 12

229. Ruth Fairbanks, "The 'Family Doctor' Had Personification in E.M. Darrow," *Fargo Forum*, February 24, 1963.

230. *Fargo Forum*, "E. Darrow Left Medical Legacy," June 15, 1975.

231. Fairbanks, "The 'Family Doctor.'"

232. Ruth Fairbanks, "First Superintendent of Health: Dr. Darrow's Efforts Curbed Disease in Early Days," *Fargo Forum*, March 3, 1963.

233. Ibid.

234. Ibid.

235. *Fargo Forum*, "E. Darrow Left Medical Legacy."

236. Ibid.

237. Ibid.

238. Ibid.

239. Ibid.

240. Ibid.

241. Bill Turkula, "Women's Lib: Old Stuff in Fargo-Moorhead," *Fargo Forum*, June 15, 1975.

242. Jim Baccus, "Dr. Weible's Retirement Ends Chapter in F-M Medical History," *Fargo Forum*, June 19, 1977, D-11.

243. *Fargo Forum*, "E. Darrow Left Medical Legacy."

244. Ibid.

245. Ibid.

246. Andrea Hunter Halgrimson, "Mary Weible Fulfilled Her Ideals," *Fargo Forum*, November 10, 2007.

247. *Fargo Forum*, "E. Darrow Left Medical Legacy."

Chapter 13

248. Henry L. Bolley, letter, 1932, Fargo, Institute for Regional Studies, *H.L. Bolley Papers*, accessed June 3, 2010.

249. Ibid.

250. Robert Wilkins, *A Century in the Northern Plains: The University of North Dakota at 100* (Grand Forks: University of North Dakota Press, 1983).

251. Louis Geiger, *University of the Northern Plains: A History of the University of North Dakota, 1883–1958* (Grand Forks: University of North Dakota Press, 1958).

252. *Fargo Forum and Daily Republican*, November 13, 1894.

253. *Grand Forks Herald*, November 13, 1894.

254. 1917–1925 College and State annual, North Dakota Agricultural College.

255. Ibid.

256. Bolley, letter.

257. Geiger, *University of the Northern Plains*.

258. Bolley, letter.

259. *Fargo Forum and Daily Republican*, November 29, 1906.

260. William C. Hunter, *Beacon Across the Prairie* (n.p.: Institute for Regional Studies, June 1961).

261. George H. Phelps, letter to North Dakota Intercollegiate Association, October 6, 1899, Institute for Regional Studies, H.L. Bolley Papers, accessed June 3, 2010.

262. *Spectrum*, January 15, 1901.

Chapter 14

263. Hunter, *Beacon Across the Prairie*.

264. Ibid.

265. Ibid.

266. *Fargo Forum*, "Second Stroke Fate for Fargoan: Husband and Daughter Accompanying Body Here for Burial," September 6, 1936. Frances Sheldon Bolley was an active community member and mourned extensively by the Fargo community. A month after her death, a Frances Sheldon Bolley Memorial Fund was established by the Florence Crittenton House Association, an organization she was president of at the time of her death. The fund was used to help "worthy, dependent girls," according to a September 28, 1936 *Fargo Forum* article.

267. Ibid., "Dr. Bolley Funeral Tuesday; Famed as Plant Scientist," November 11, 1956.

268. Beloit College, "Melvin Amos Brannon," accessed June 3, 2010, www. beloit.edu/archives/history/presidents/melvin_brannon.

269. Derek Johnson, "Dobie, Gilmour (1879–1948), Football Coach," 2002, accessed June 5, 2010, www.historylink.org/File/3693.

270. Ibid.

271. Ibid.

272. Ibid.

Chapter 15

273. 1949 Bison annual, "Rahjah Club," North Dakota State University.

274. 1950 Bison annual, "Rahjah Club," North Dakota State University.

275. 1951 Bison annual, "Rahjah Club," North Dakota State University.

276. *Dakota Student*, November 30, 1956.

277. 1957 Dacotah yearbook, "Golden Feathers," University of North Dakota.

278. 1959 Dacotah yearbook, "Golden Feathers," University of North Dakota.

279. *Spectrum*, October 2, 1959.

280. Ibid.

281. 1963 Dacotah yearbook, "Golden Feathers," University of North Dakota.

282. *Spectrum*, October 12, 1967.

283. *Dakota Student*, October 11, 1968.

284. Ibid.

285. Ibid.

286. Ibid., November 1, 1968.

287. *Spectrum*, February 1969.

288. *Dakota Student*, November 3, 1970.

289. Ibid., Letter to the Editor, December 10, 1971.

290. *Spectrum*, January 13, 1976.

291. *Dakota Student*, September 30, 1983.

Chapter 16

292. Roy P. Johnson, "John Haggart Had Colorful Career as Frontier Marshall," *Forum of Fargo-Moorhead*, June 4, 1950.

293. Roy P. Johnson, "Haggart Devoted to Horse Trade," *Forum of Fargo-Moorhead*, December 31, 1978, D-4.

294. Johnson, "John Haggart Had Colorful Career."

295. Ibid.

296. Ibid.

297. Roy P. Johnson, "Fargo Votes Haggart Most Popular Man," *Forum of Fargo-Moorhead*, January 7, 1979, C-4.

298. Johnson, "John Haggart Had Colorful Career."

299. Ibid.

300. Clement Lounsberry, *Early History of North Dakota* (Washington, D.C.: Liberty Press, 1910), 211.

301. "Hon. John E. Haggart," Institute for Regional Studies Collection.

302. Frank A. Ball, "John E. Haggart," *Collections of the State Historical Society of North Dakota* (Bismarck: State Historical Society of North Dakota, 1906), 334.

303. Ibid., 335.

Chapter 17

304. Fargo, North Dakota: Its History and Images, "The Divorce Capital of the West," accessed August 27, 2016, library.ndsu.edu/fargo-history/?q=content/divorce-capital-west.

305. Alma E. Riggle, "Divorce Colony Featured One Fargo Era," *Fargo Forum*, April 11, 1935.

306. Ibid.

307. Ibid.

308. April White, "The Divorce Colony," *Atavist Magazine* 55, accessed August 27, 2016, read.atavist.com/the-divorce-colony.

309. Riggle, "Divorce Colony Featured One Fargo Era."

310. Ibid.

311. *Bismarck Tribune*, "Bishop Fought 'Divorce Capital of America,'" December 20, 2008.

312. Ibid.

Chapter 18

313. Curt Eriksmoen, "Lincoln's Bodyguard Became N.D. Politician," *Sunday Forum*, July 24, 2005, A21.
314. Smith Stimmel, *Personal Reminisces of Abraham Lincoln* (n.p.: Riverside Press, 1928), 10.
315. Ibid.
316. Ibid.
317. Ibid.
318. Ibid., 17.
319. Ibid.
320. Ibid.
321. Ibid., 19.
322. Ibid., 36.
323. Ibid., 40.
324. Alden McLachlan, "Onetime Fargoan Lincoln Guard," *Sunday Forum*, n.d.
325. Stimmel, *Personal Reminisces of Abraham Lincoln*, 40. It should be noted that those initial reports were incorrect because Seward survived the shooting.
326. McLachlan, "Onetime Fargoan Lincoln Guard."
327. Stimmel, *Personal Reminisces of Abraham Lincoln*, 12.
328. Eriksmoen, "Lincoln's Bodyguard," A21.
329. Ibid.
330. Ibid.
331. Ibid.
332. Ibid.
333. *Dickinson Press*, "Grandson of Lincoln Bodyguard Pays Respects in Fargo," April 1, 2007, A1.
334. Frank J. Williams, "At Lincoln's Side: Smith Stimmel's Personal Reminiscences of Abraham Lincoln," *North Dakota History* 74 (July 2007): 3.
335. Ibid.
336. Stimmel, *Personal Reminisces of Abraham Lincoln*, 12.
337. Ibid.

Chapter 19

338. Andrea Hunter Halgrimson, "Crystal Ballroom Had Event-Filled History," *Forum*, August 6, 2005, B1.

339. Bob Lind, "Crystal Ballroom Owner's Daughter Recalls Duke Ellington's Trip to Fargo," *Forum of Fargo-Moorhead*, July 13, 2014, C11. Schafer would later move to Bismarck and marry Harold Schafer, founder of the Gold Seal Wax Co. and developer of Medora, North Dakota, as a tourist attraction. She was stepmother to former governor Ed Schafer. Dubbed the "First Lady of Medora," Schafer passed away in 2016.

340. Ibid., C11.

341. Martin C. Fredricks, "The Duke in the Dakotas: SDSC Alums Save Piece of Jazz History," *North Dakota State University Magazine*, Fall 1999, 18.

342. Ibid.

343. Ibid.

344. William Johnson, "Scrapbook Will Last After the Ball Is Over," *Minneapolis Sunday Tribune*, February 18, 1962, 2.

345. Dorothy Bangert Bacheller, letter, December 24, 1998.

346. Lind, "Crystal Ballroom Owner's Daughter," C11.

347. Johnson, "Scrapbook Will Last," 2.

348. Undated transcript of Sheila Schafer interview, North Dakota Institute for Regional Studies.

349. Jonathan Knutson, "Crystal Ballroom Centerpiece of Ramada's Expansion," *Forum of Fargo-Moorhead*, November 8, 1997, B1.

Appendix B

350. *Fargo Forum*, "North Dakota Institute of Regional Studies Launched by Faculty Group of NDAC to Record Growth of State," April 30, 1950.

351. Ibid., "Train Display Tells Story of AC Institute," June 28, 1952.

352. Ibid., "Letters Added to Regional Studies Lore," April 10, 1955.

353. Louis Dussere, "Bonanza Farm Fact-Finding," *Fargo Forum*, January 14, 1961.

354. Cheryl Ellis, "SU Archives Face Squeeze," *Fargo Forum*, May 13, 1973.

355. Sarah Comber, "Trial by Water, Flooding of NDSU Library Comes during Director's First Week on the Job," *Fargo Forum*, June 26, 2000.

356. Andrea Hunter Halgrimson, "NDSU Once Again Relocates Its Archives," *Fargo Forum*, March 30, 2014.

357. Ibid.

Appendix C

358. Father Louis Pfaller, "Roy P. Johnson—Red River Valley Historian," *Red River Valley Historian,* June 1967, 1, 3.

359. Patrick Springer, "Halgrimson, Forum Columnist with 'Lucky' Life, Dead at 74," *Forum of Fargo-Moorhead*, February 24, 2015.

360. Pfaller, "Roy P. Johnson," 1, 3.

INDEX

About the Author

Danielle Teigen is a South Dakota girl living in North Dakota. That's where she went to earn a degree in journalism as well as a master's degree in mass communication from North Dakota State University. Thanks to those degrees (and an insatiable love of reading), Danielle is a word nerd. She considers it a hazard of the trade—she's a professional communicator with a background in journalism, marketing and public relations. She has worked as a magazine editor for two local publications, as well as senior communications strategist for an engineering firm. She worked for the local chamber of commerce before leaving to put her skills and experiences to use in her job as features editor for Forum Communications in Fargo.

In addition to writing for the *Forum of Fargo-Moorhead*, Danielle has written for local magazines *The Good Life*, *Lake and Home Magazine*, *Bison Illustrated* magazine, *From House to Home* magazine and *Wedding Vow* magazine.

She lives in Fargo with her husband and two children.

Visit us at
www.historypress.net
..
This title is also available as an e-book